Robert Frost's

Betsy and Tom Melvin

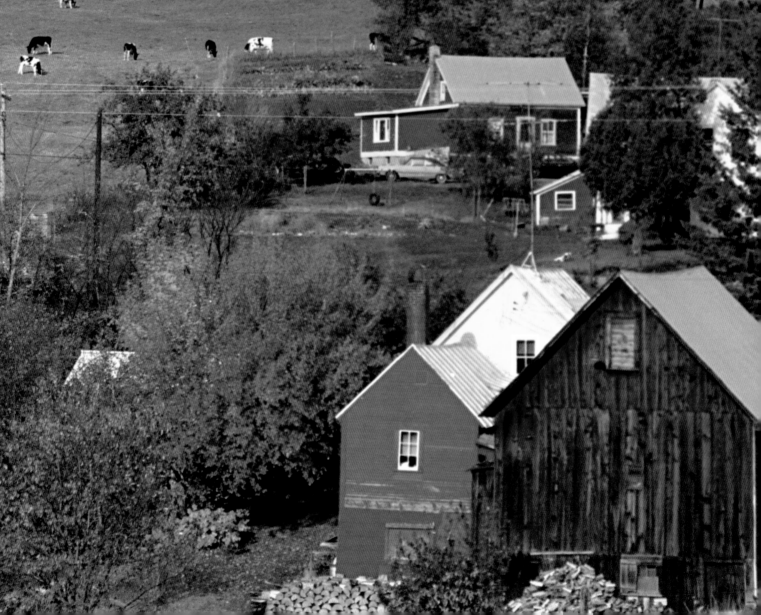

New England

Foreword by Jay Parini

University Press of New England

HANOVER AND LONDON

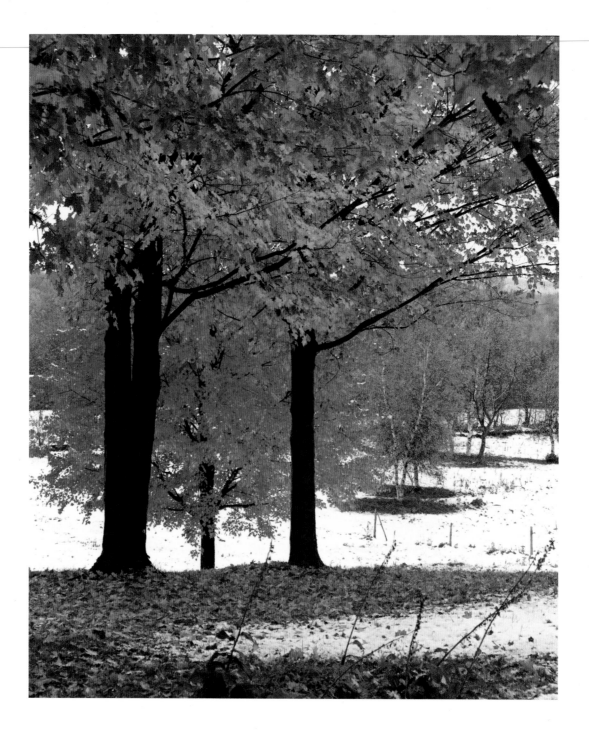

Contents

Author's Note

A Note on the Texts

The texts presented here are those from first editions of *A Boy's Will, North of Boston,* and *Mountain Interval.* The texts of the poems Frost later included in *New Hampshire* are faithful to their first printings in periodicals, as are the texts of two early poems that were not originally collected in book form.

Acknowledgments

I cannot forget my friend Ted Sirlin (later the national president of the Professional Photographers of America), who said to me, "Betsy, you ought to correlate your poetic photographs to Robert Frost's Vermont Poetry!"

We thank Jo Ann Langone, whose work for the University Press of New England first inspired us to visit them. We especially appreciate the enthusiasm, sensitivity, and guidance of the staff in Hanover.

We are grateful that our daughters, Holly, Janet, Hedy, and Nini, always support and take pride in our artistic endeavors.

We thank our friends at Photographers' Color Service who, for three decades, have provided us with the finest quality color photographs.

January 2000 B.B.M.

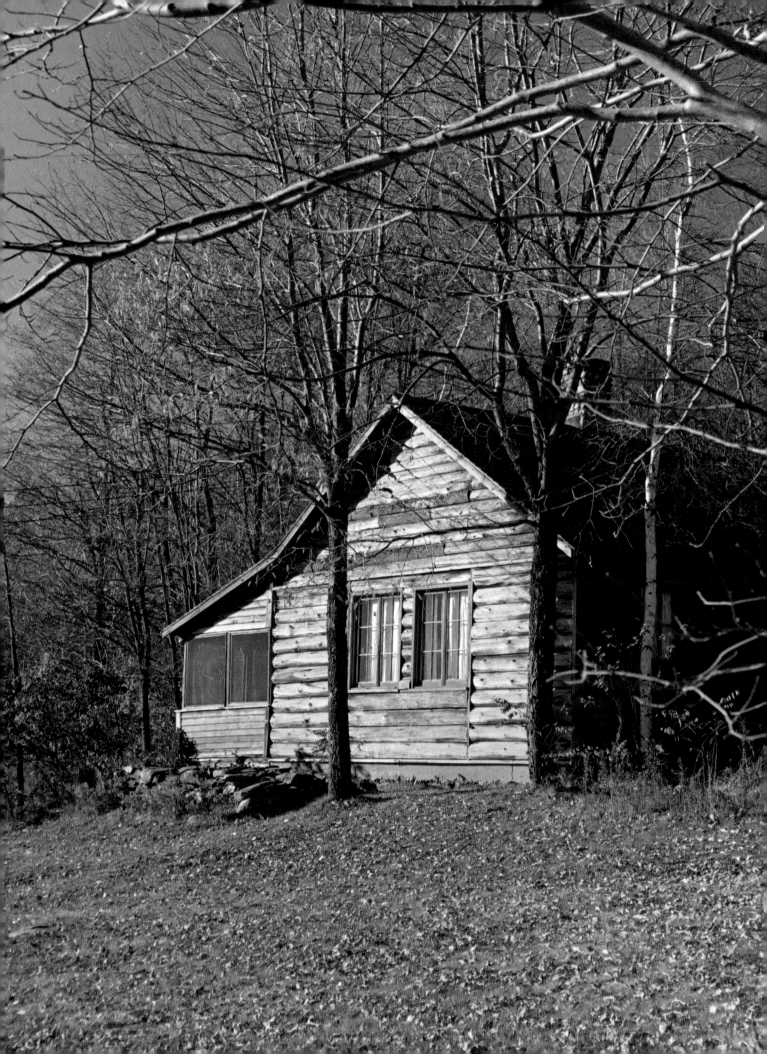

Foreword

JAY PARINI

"Image and after-image are all there is to poetry," Robert Frost once said. The comment suggests that he would have appreciated this gathering of photographs by Betsy and Tom Melvin. They have caught, as if seized by a parallel force, the imagery of Frost's rural New England, a landscape that exists more completely in the imagination of the poet or photographer than anywhere that could be found on a map. As Frost jotted in a notebook at the outset of his career: "Locality gives art."

Frost was deeply Emersonian. That is, through his mother he had come to Ralph Waldo Emerson through Swedenborg, the seventeenth-century Swedish mystic. Belle Moody Frost, herself a Scot, was a devout Swedenborgian. She taught her children, Robbie and Jean, the Swedenborgian doctrine of correspondence—the notion that every sign or pictorial image in the physical world points to some spiritual reality. Spirit and nature deeply mingle in the Swedenborgian universe, as they do in Frost's poetry. Emerson, who admired Swedenborg, wrote that he, "of all men in the recent ages, stands eminently for the translator of nature into thought." In his seminal book, *Nature* (1836), he declared: "Nature is the symbol of the spirit." Elaborating in an essay called "The Poet," he explained: "There is no fact in nature which does not carry the whole sense of nature."

All natural facts, whether birds, trees, or mountains, may be taken as signs of spiritual facts. Therefore, the work of seeing—of vision—becomes the essential activity of the artist, whether poet or photographer. "Cast your thoughts upon the object," Emerson directed the beginning poet. That is certainly what Frost did, visualizing the region north of Boston with such accuracy and physicality that he gave (in Shakespeare's formulation) "a local habitation and name" to a place that acquired a spiritual dimension in the act of seeing.

As anyone leafing through this volume will notice, Frost's vision inspired the Melvins, who have a gift for prizing and delimiting the ideal image, whether it be a leafless tree against a bare sky, a sloping dune of snow, a field of wildflow-

ers, or a pathless wood. These photographs are a testament to the artists' power of delimiting; that is, the artists have found their proper subject, the image, separating each pictorial unit from the surrounding visual clutter.

Frost, of course, was the master of this process; thus, in "The Tuft of Flowers," he could describe with ferocious concentration "A leaping tongue of bloom that scythe had spared / Beside a reedy brook the scythe had bared." In writing this, he uncovered a natural image that shimmers in a concrete singularity corresponding to a "leaping tongue of bloom" we have all experienced on walks through a summery woods, but as much inside of ourselves as "out there." Nature is, indeed, the symbol of the spirit.

I take the Melvins' book as an anthology of emotional and spiritual states. Responding to the contours of a beloved landscape, they have uncovered a sequence of essences. Not surprisingly, they have focused on the shift of seasons, on weather (the symbol for mood) as it cycles over the landscape from "bare November days" through winter's "desolate deserted trees" to abundant spring with bees a "swarm dilating" to the exaltations of summer. Movingly, their sequence of photographs and poetry ends "in a yellow wood"—perhaps the most vivid mental image Frost ever summoned from the thickets of his imagination. I expect that many readers, like me, will delight in these pages, feeling grateful to the Melvins for assembling this collection, a happy and unexpected coordination of images, linguistic and photographic.

Robert Frost's New England

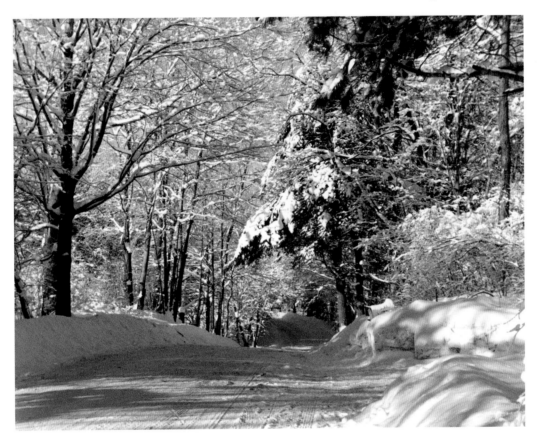

from October

O hushed October morning mild,
Begin the hours of this day slow,
Make the day seem to us less brief.
Hearts not averse to being beguiled,
Beguile us in the way you know;
Release one leaf at break of day;
At noon release another leaf;
One from our trees, one far away;
Retard the sun with gentle mist;
Enchant the land with amethyst.

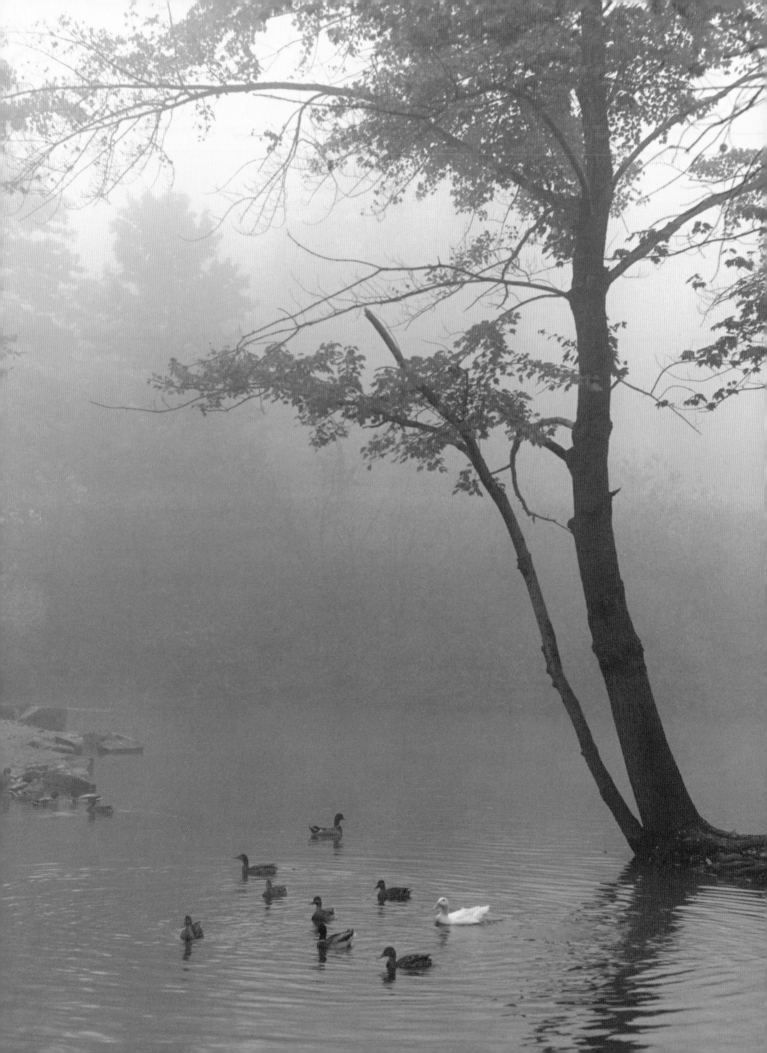

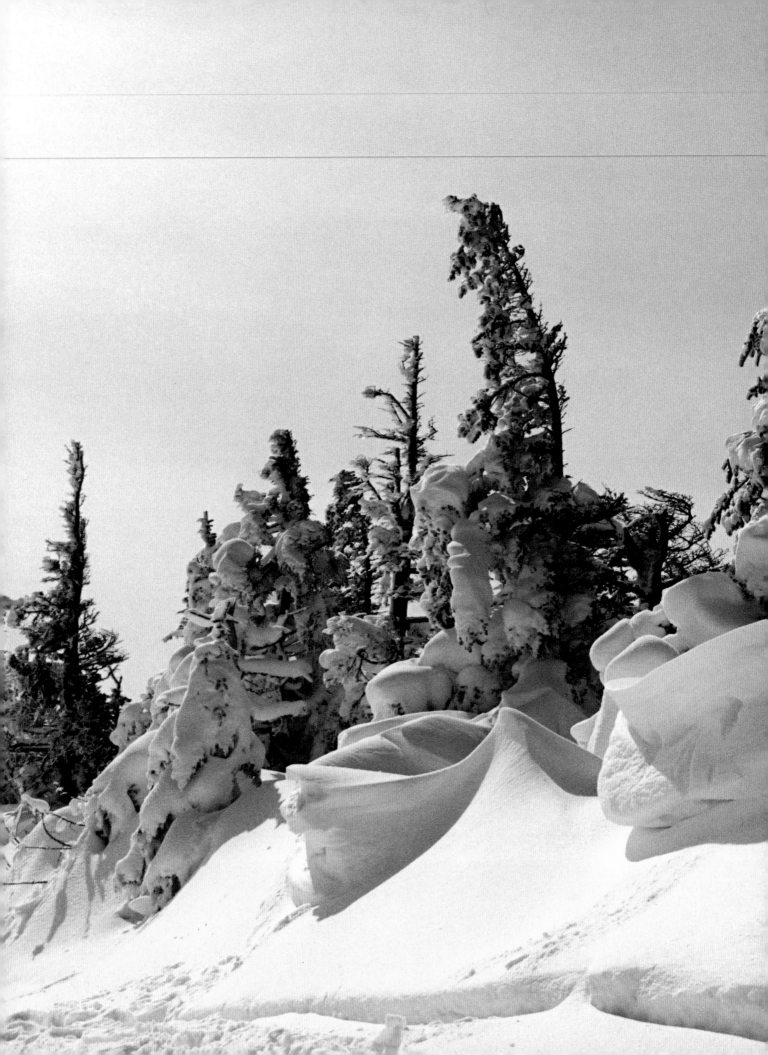

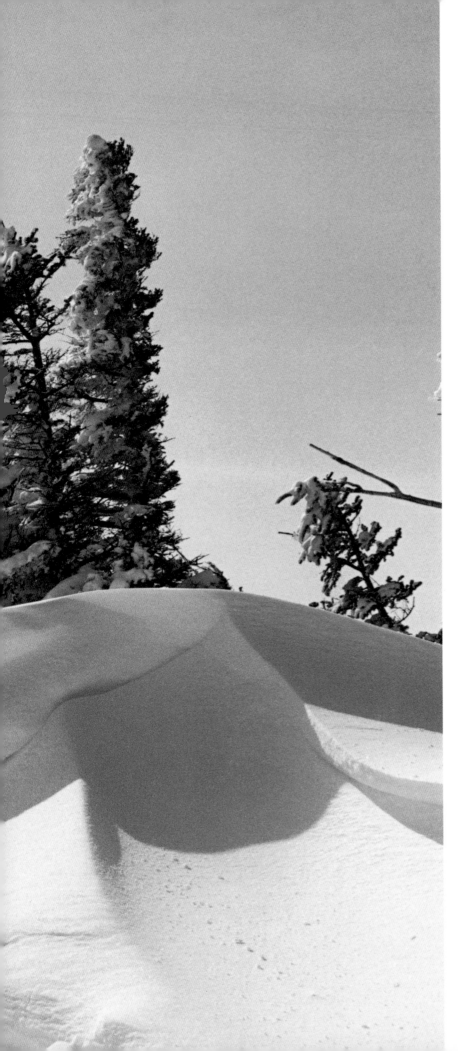

from Wind and Window Flower

He was a winter wind,
 Concerned with ice and snow.

from The Death of the Hired Man

Part of a moon was falling down the west,
Dragging the whole sky with it to the hills.

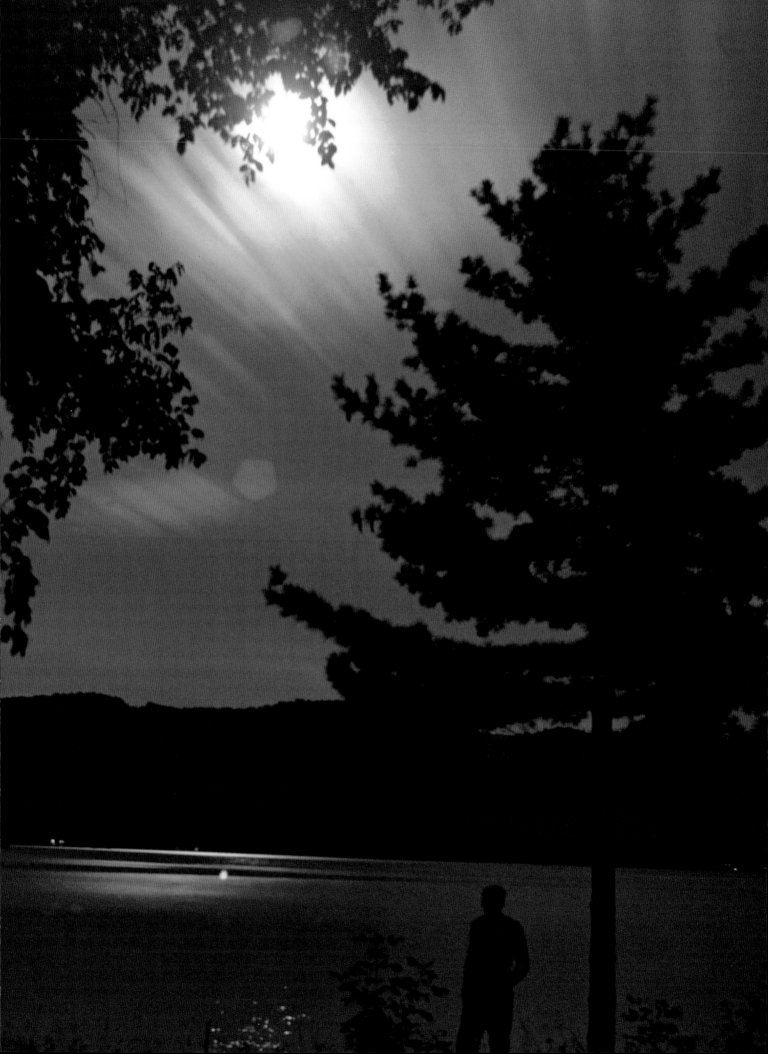

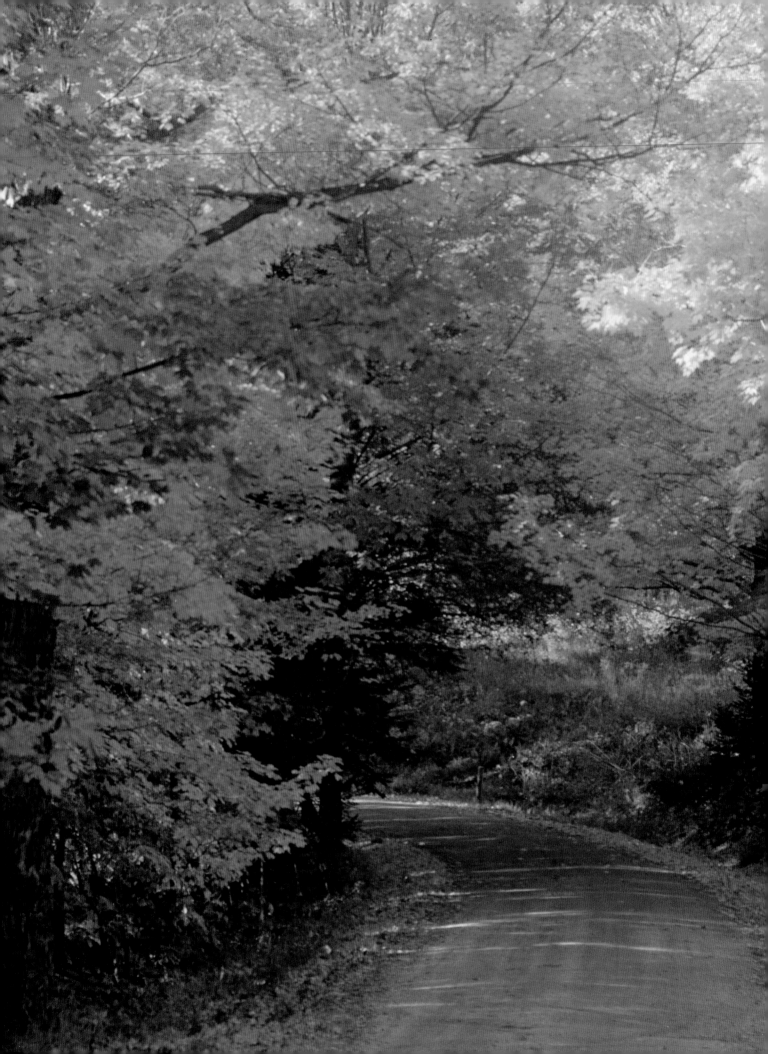

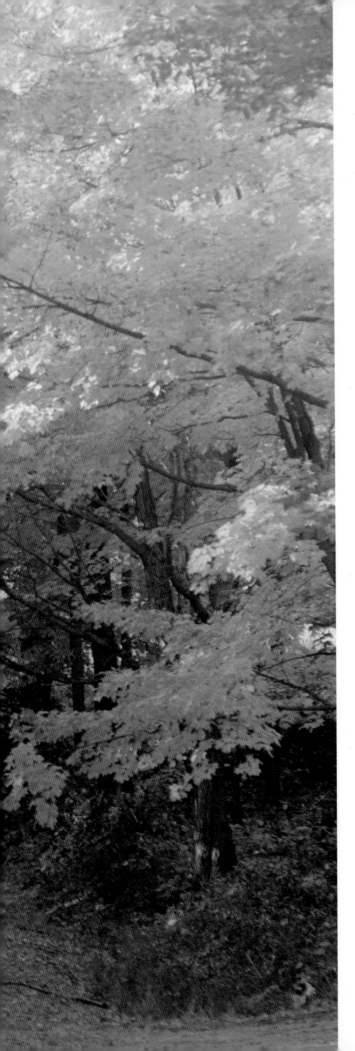

from A Dream Pang

I had withdrawn in forest, and my song
Was swallowed up in leaves that blew away . . .

from Going for Water

We heard, we knew we heard the brook.

A note as from a single place,
 A slender tinkling fall that made
Now drops that floated on the pool
 Like pearls, and now a silver blade.

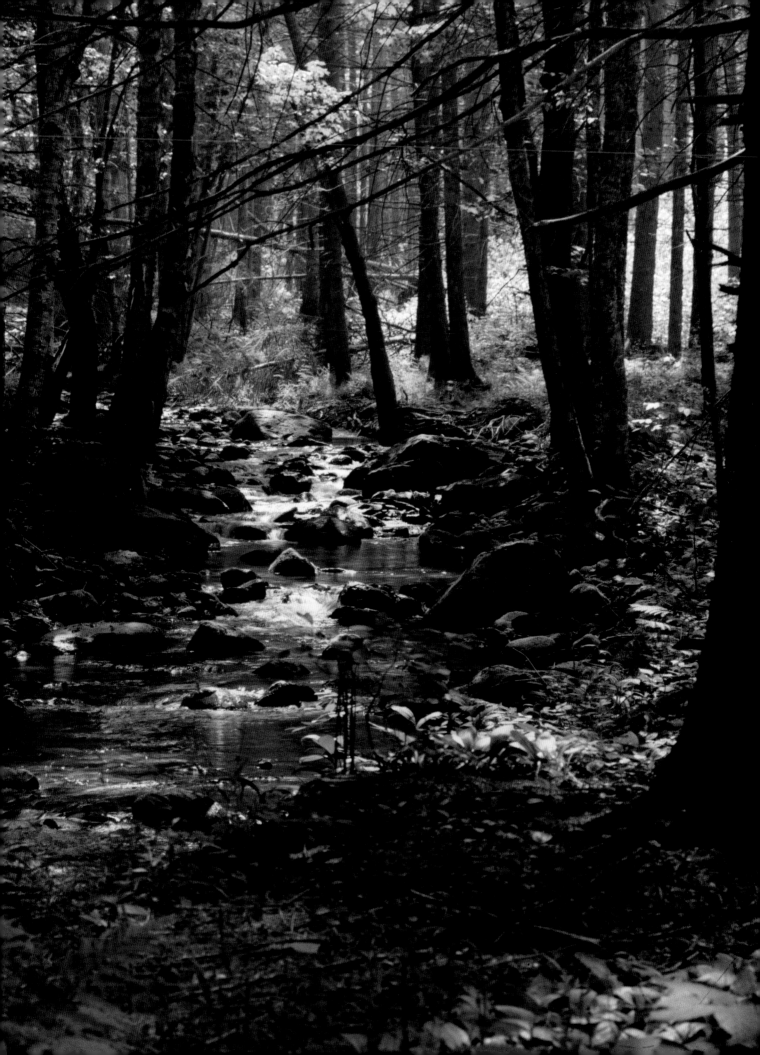

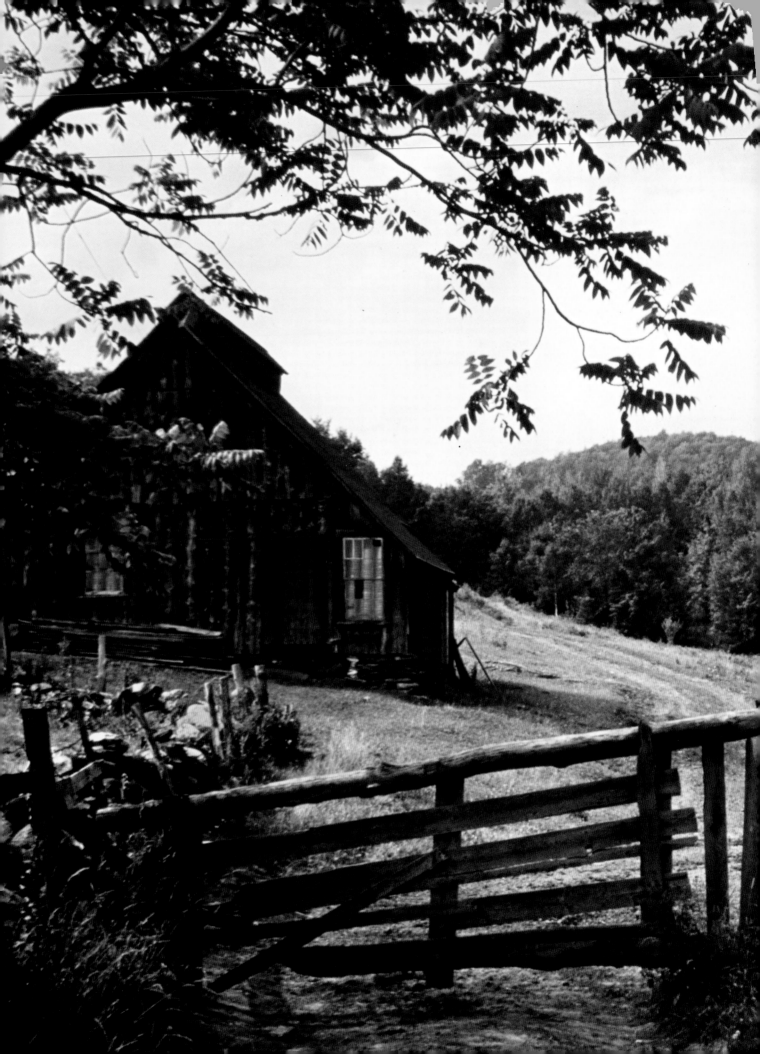

from The Wood-Pile

It was a cord of maple, cut and split
And piled—and measured, four by four by eight.

Mending Wall

Something there is that doesn't love a wall,
That sends the frozen-ground-swell under it,
And spills the upper boulders in the sun;
And makes gaps even two can pass abreast.
The work of hunters is another thing:
I have come after them and made repair
Where they have left not one stone on stone,
But they would have the rabbit out of hiding,
To please the yelping dogs. The gaps I mean,
No one has seen them made or heard them made,
But at spring mending-time we find them there.
I let my neighbor know beyond the hill;
And on a day we meet to walk the line
And set the wall between us once again.
We keep the wall between us as we go.
To each the boulders that have fallen to each.
And some are loaves and some so nearly balls
We have to use a spell to make them balance:
"Stay where you are until our backs are turned!"
We wear our fingers rough with handling them.
Oh, just another kind of out-door game,
One on a side. It comes to little more:
There where it is we do not need the wall:
He is all pine and I am apple orchard.
My apple trees will never get across
And eat the cones under his pines, I tell him.
He only says, "Good fences make good neighbors."
Spring is the mischief in me, and I wonder
If I could put a notion in his head:
"*Why* do they make good neighbors? Isn't it
Where there are cows? But here there are no cows.
Before I built a wall I'd ask to know
What I was walling in or walling out,
And to whom I was like to give offense.
Something there is that doesn't love a wall,
That wants it down." I could say "Elves" to him,
But it's not elves exactly, and I'd rather
He said it for himself. I see him there
Bringing a stone grasped firmly by the top
In each hand, like an old-stone savage armed.
He moves in darkness as it seems to me,
Not of woods only and the shade of trees.
He will not go behind his father's saying,
And he likes having thought of it so well
He says again, "Good fences make good neighbors."

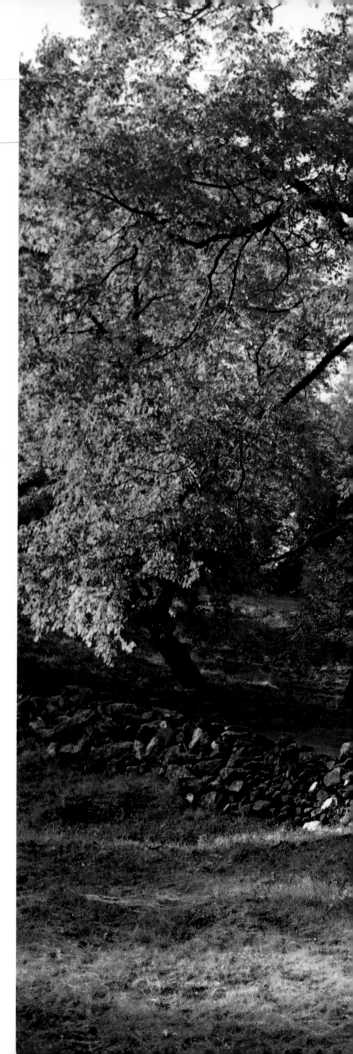

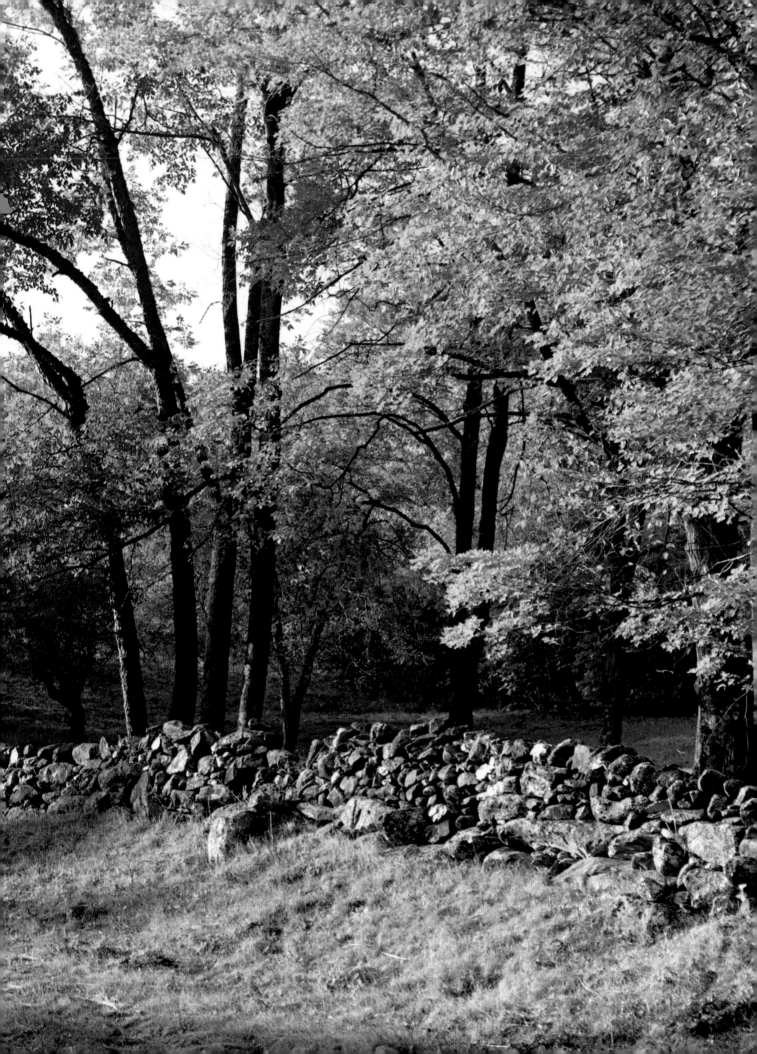

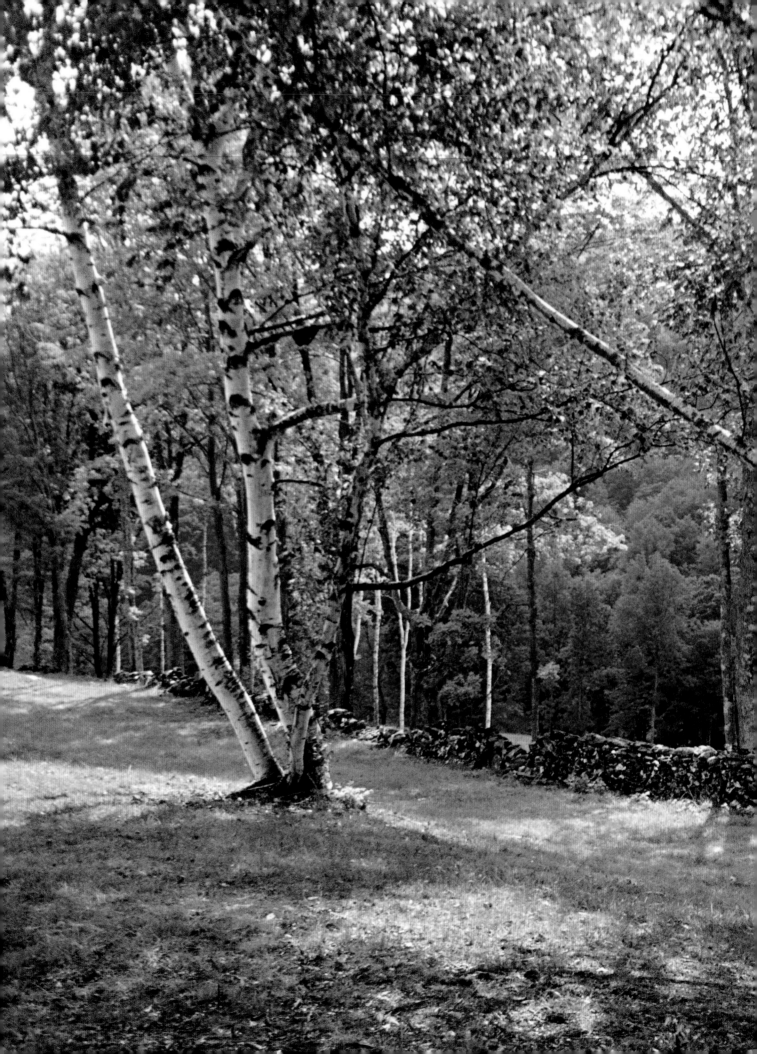

from A Star in a Stoneboat

Some may know what they seek in school and church,
And why they seek it there; for what I search
I must go measuring stone walls, perch on perch . . .

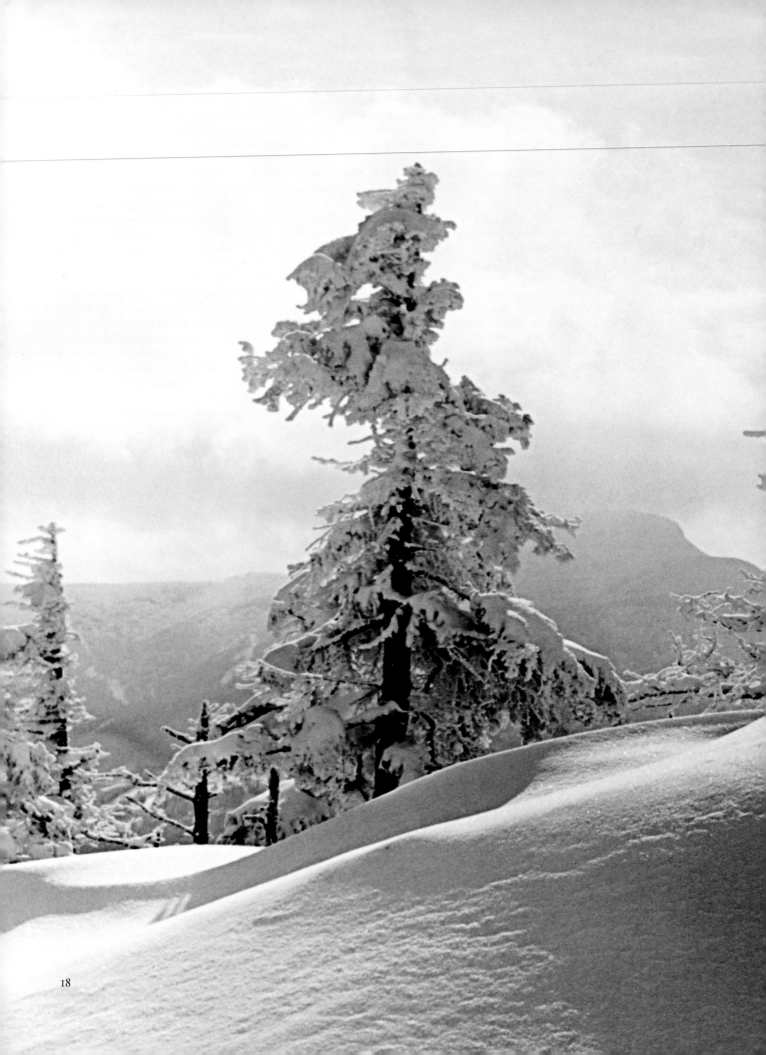

Fire and Ice

Some say the world will end in fire,
Some say in ice.
From what I've tasted of desire
I hold with those who favor fire.
But if it had to perish twice,
I think I know enough of hate
To know that for destruction ice
Is also great
And would suffice.

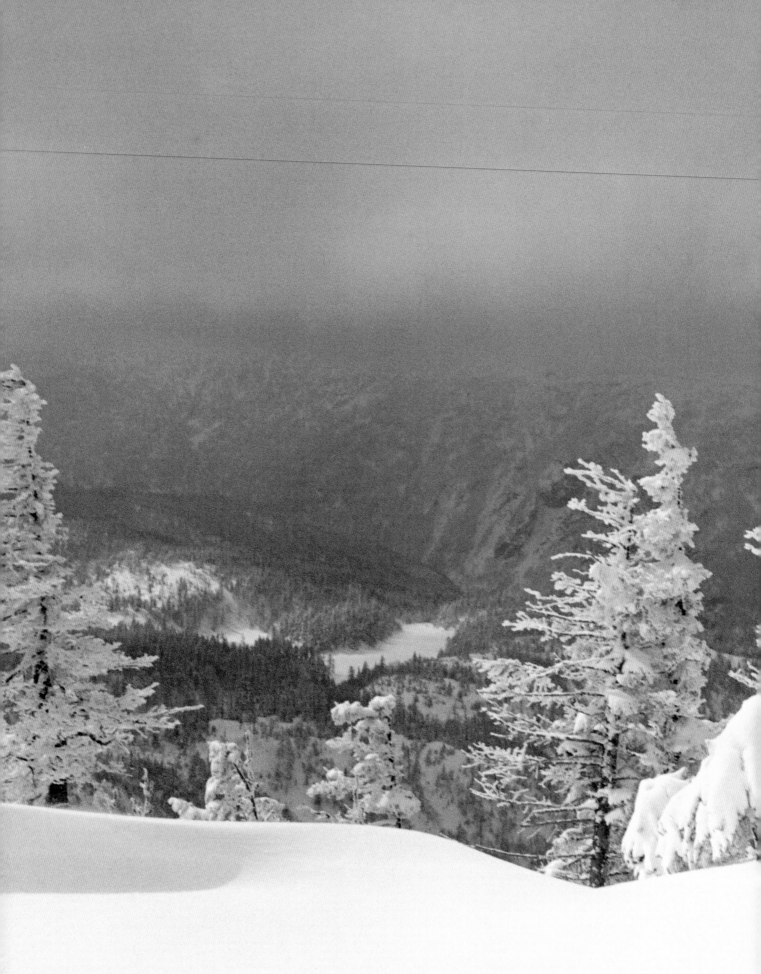

from Snow

"Our snow-storms as a rule
Aren't looked on as man-killers, and although
I'd rather be the beast that sleeps the sleep
Under it all, his door sealed up and lost,
Than the man fighting it to keep above it,
Yet think of the small birds at roost and not
In nests. Shall I be counted less than they are?
Their bulk in water would be frozen rock
In no time out to-night. And yet to-morrow
They will come budding boughs from tree to tree
Flirting their wings and saying Chickadee,
As if not knowing what you meant by the word storm."

Stopping by Woods on a Snowy Evening

Whose woods these are I think I know.
His house is in the village though;
He will not see me stopping here
To watch his woods fill up with snow.

The little horse must think it queer
To stop without a farmhouse near
Between the woods and frozen lake
The darkest evening of the year.

He gives his harness bells a shake
To ask if there is some mistake.
The only other sound's the sweep
Of easy wind and downy flake.

The woods are lovely, dark and deep,
But I have promises to keep,
And miles to go before I sleep,
And miles to go before I sleep.

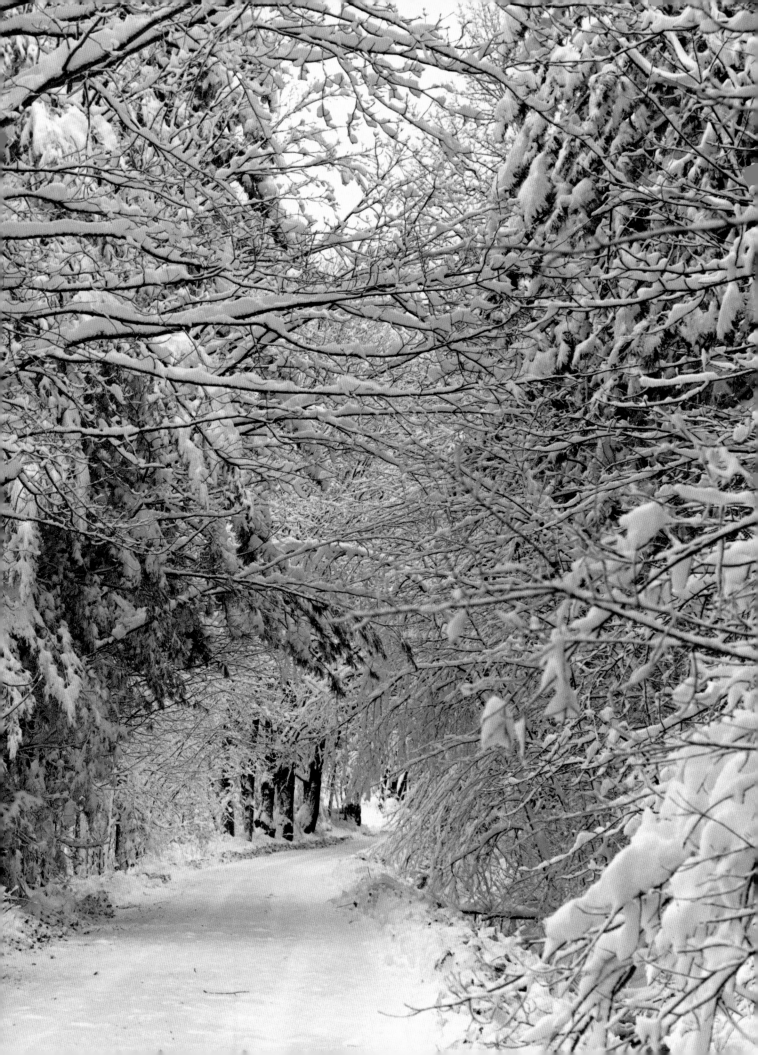

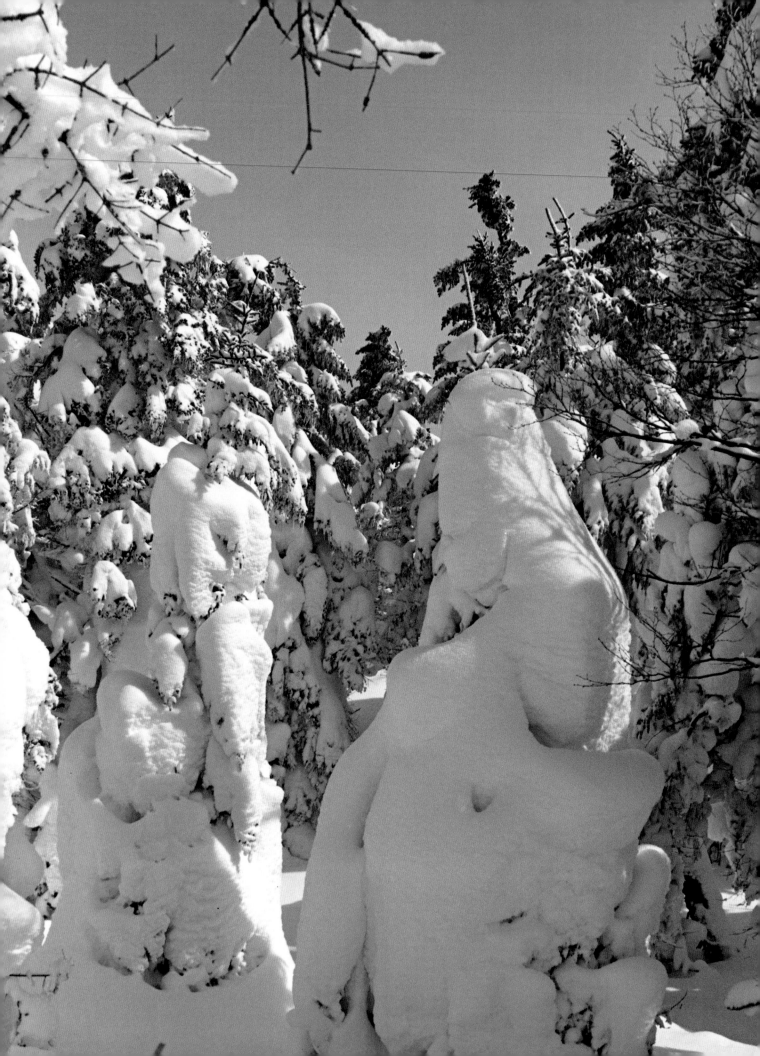

Snow Dust

The way a crow
Shook down on me
The dust of snow
From a hemlock tree

Has given my heart
A change of mood
And saved some part
Of a day I had rued.

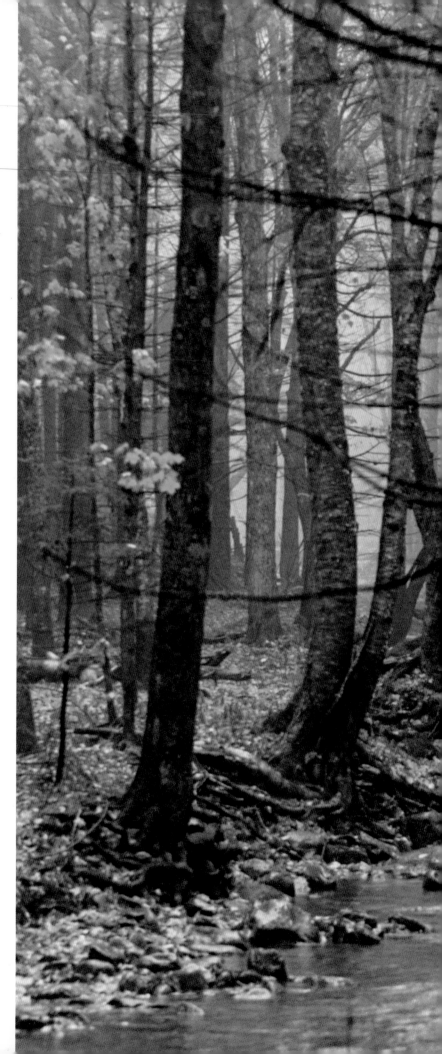

My November Guest

My Sorrow, when she's here with me,
 Thinks these dark days of autumn rain
Are beautiful as days can be;
She loves the bare, the withered tree;
 She walks the sodden pasture lane.

Her pleasure will not let me stay.
 She talks and I am fain to list:
She's glad the birds are gone away,
She's glad her simple worsted gray
 Is silver now with clinging mist.

The desolate, deserted trees,
 The faded earth, the heavy sky,
The beauties she so truly sees,
She thinks I have no eye for these,
 And vexes me for reason why.

Not yesterday I learned to know
 The love of bare November days
Before the coming of the snow,
But it were vain to tell her so,
 And they are better for her praise.

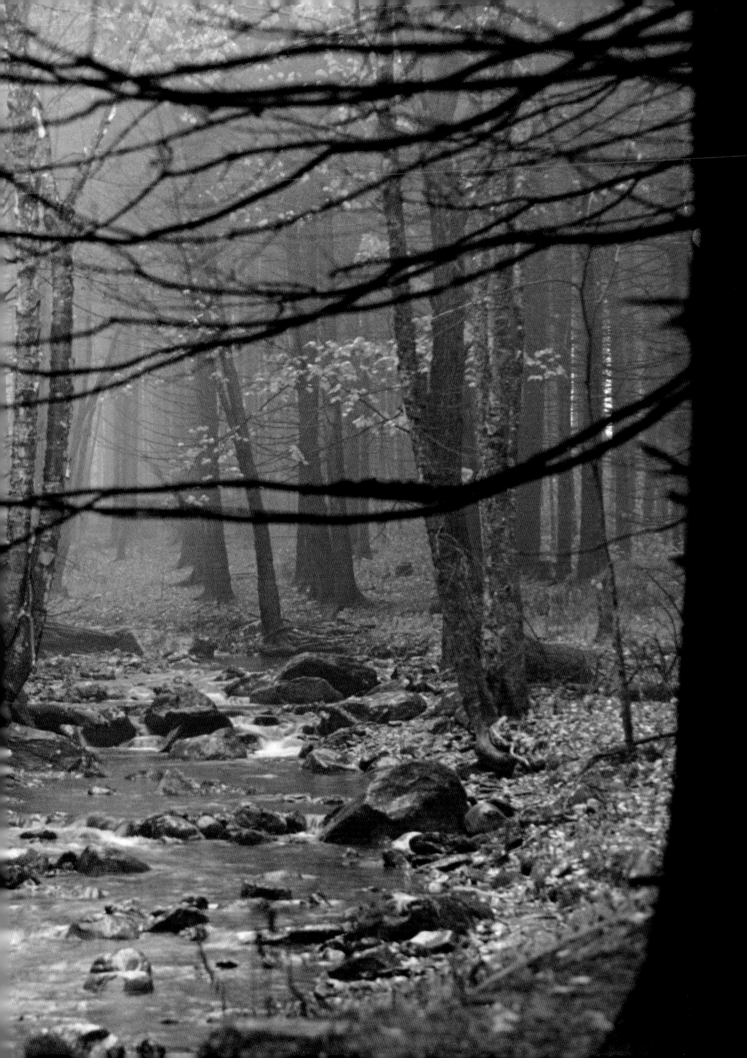

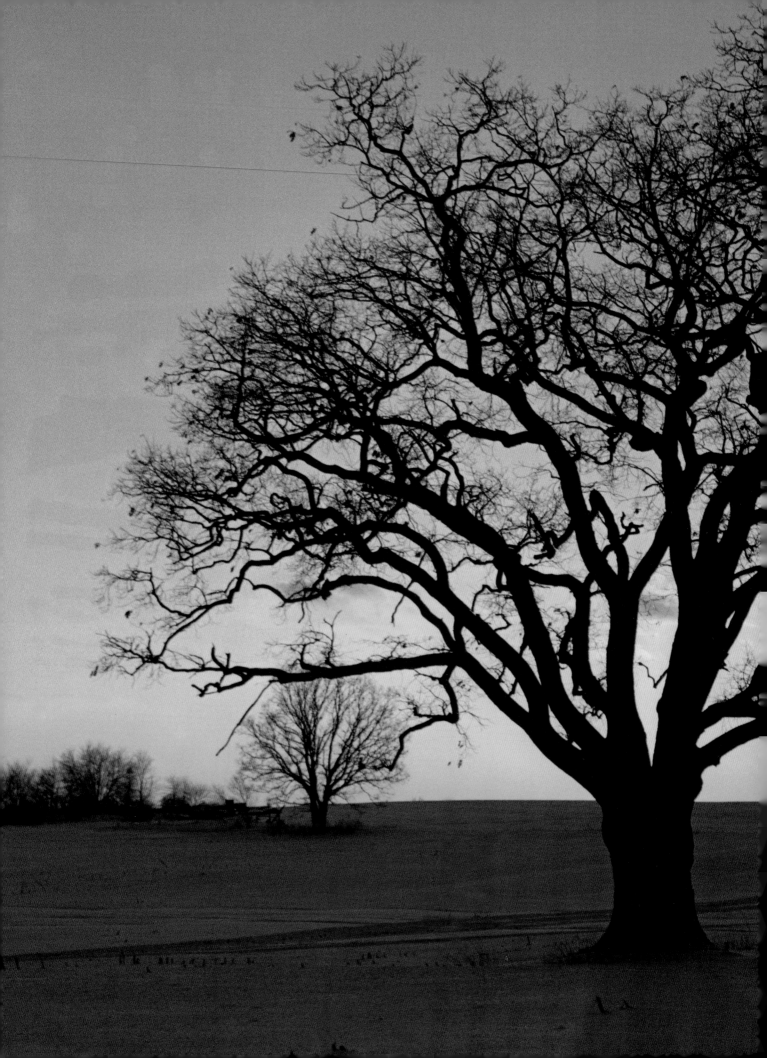

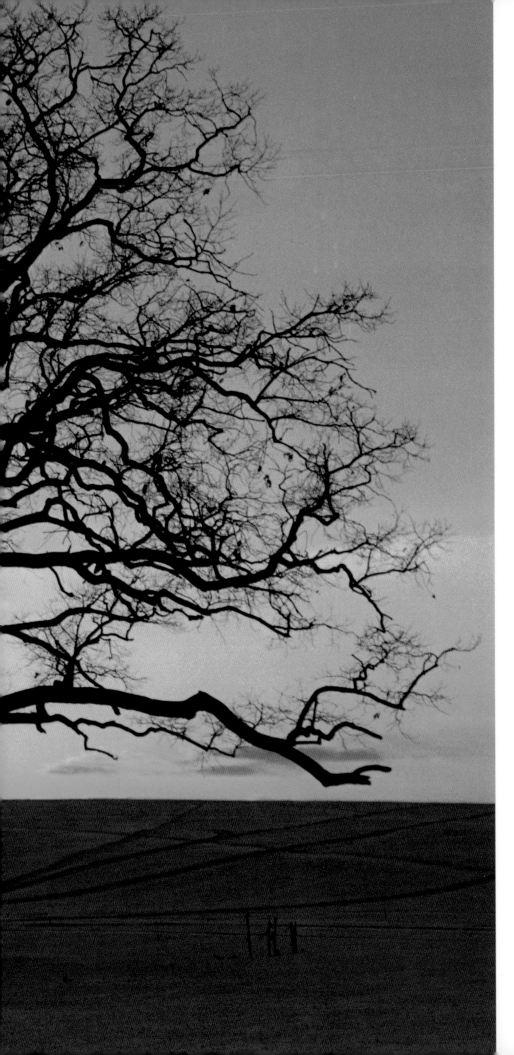

Nothing Gold Can Stay

Nature's first green is gold,
Her hardest hue to hold.
Her early leaf's a flower;
But only so an hour.
Then leaf subsides to leaf.
So Eden sank to grief,
So dawn goes down to day.
Nothing gold can stay.

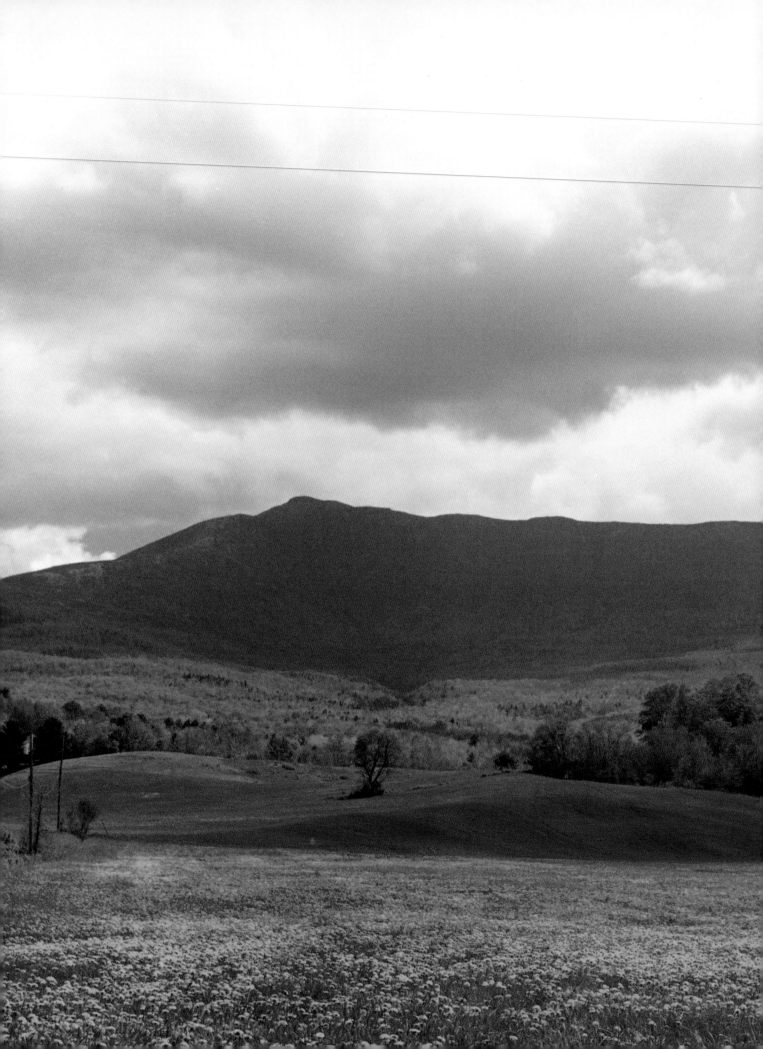

from A Prayer in Spring

Oh, give us pleasure in the flowers to-day;
And give us not to think so far away
As the uncertain harvest; keep us here
All simply in the springing of the year.

from A Prayer in Spring

Oh, give us pleasure in the orchard white,
Like nothing else by day, like ghosts by night;
And make us happy in the happy bees,
The swarm dilating round the perfect trees.

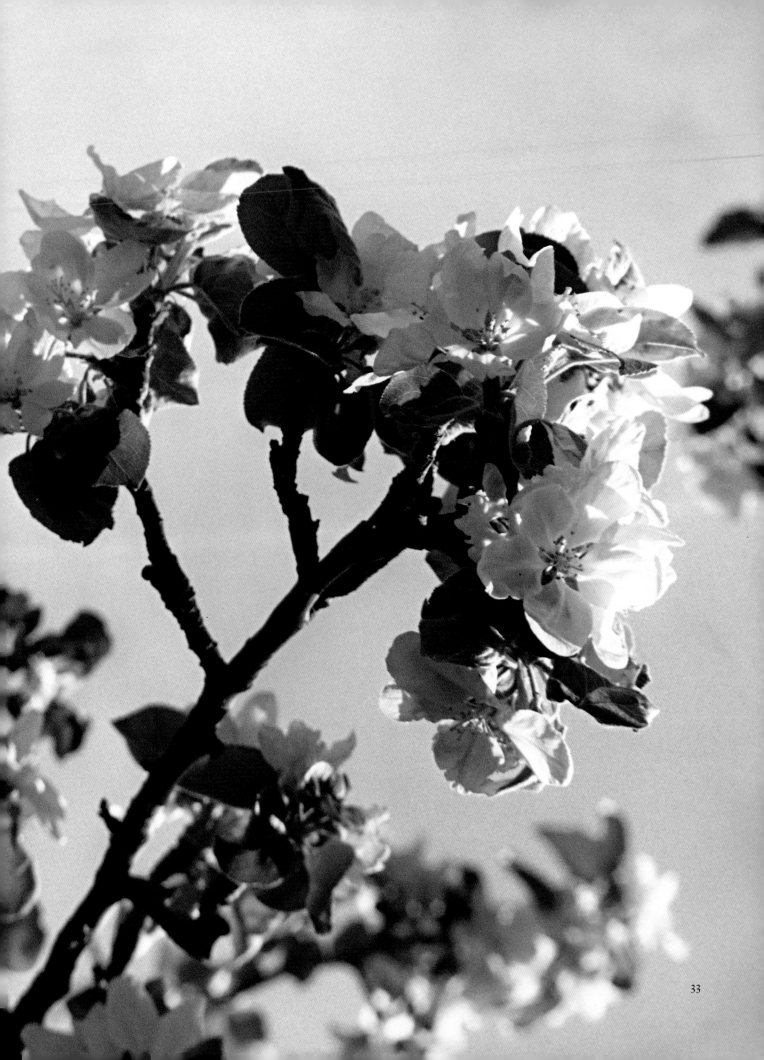

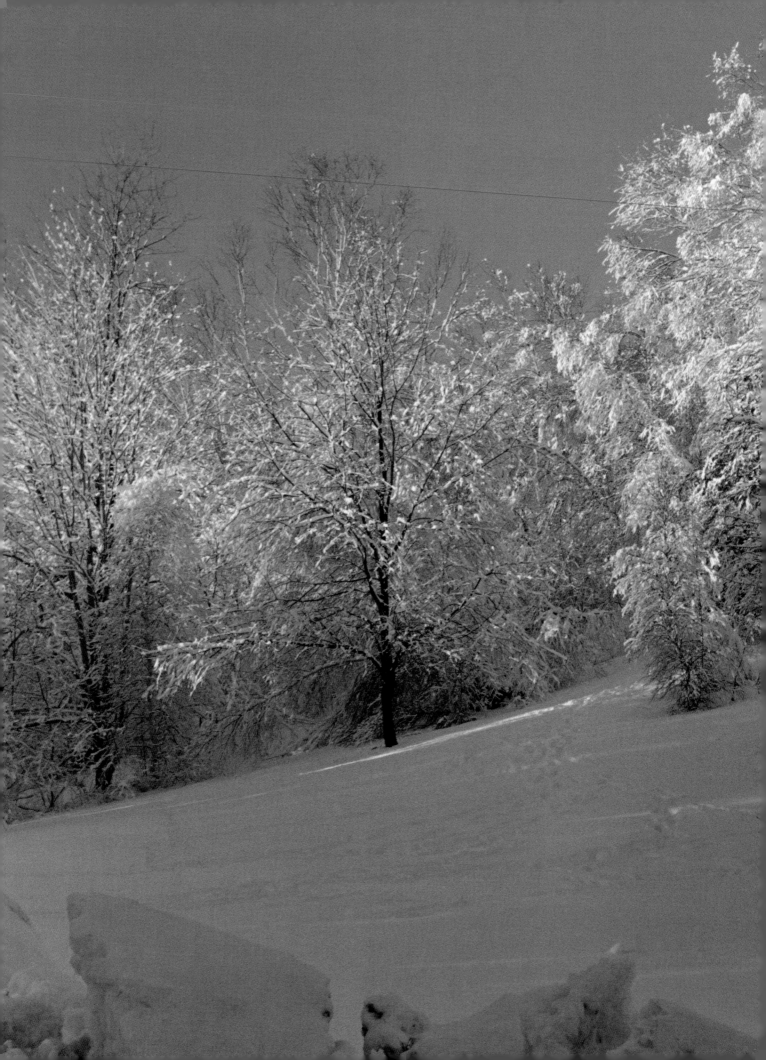

Good-by and Keep Cold

This saying good-by on the edge of the dark
And cold to an orchard so young in the bark
Reminds me of all that can happen to harm
An orchard away at the end of the farm
All winter, cut off by a hill from the house.
I don't want it girdled by rabbit and mouse,
I don't want it dreamily nibbled for browse
By deer, and I don't want it budded by grouse.
(If certain it wouldn't be idle to call
I'd summon grouse, rabbit, and deer to the wall
And warn them away with a stick for a gun.)
I don't want it stirred by the heat of the sun.
(We made it secure against being, I hope,
By setting it out on a northerly slope.)
No orchard's the worse for the wintriest storm;
But one thing about it, it mustn't get warm.
"How often already you've had to be told,
Keep cold, young orchard. Good-by and keep cold.
Dread fifty above more than fifty below."
I have to be gone for a season or so.
My business awhile is with different trees,
Less carefully nourished, less fruitful than these,
And such as is done to their wood with an ax—
Maples and birches and tamaracks.
I wish I could promise to lie in the night
And think of an orchard's arboreal plight
When slowly (and nobody comes with a light)
Its heart sinks lower under the sod.
But something has to be left to God.

from After Apple-Picking

there may be two or three
Apples I didn't pick upon some bough.

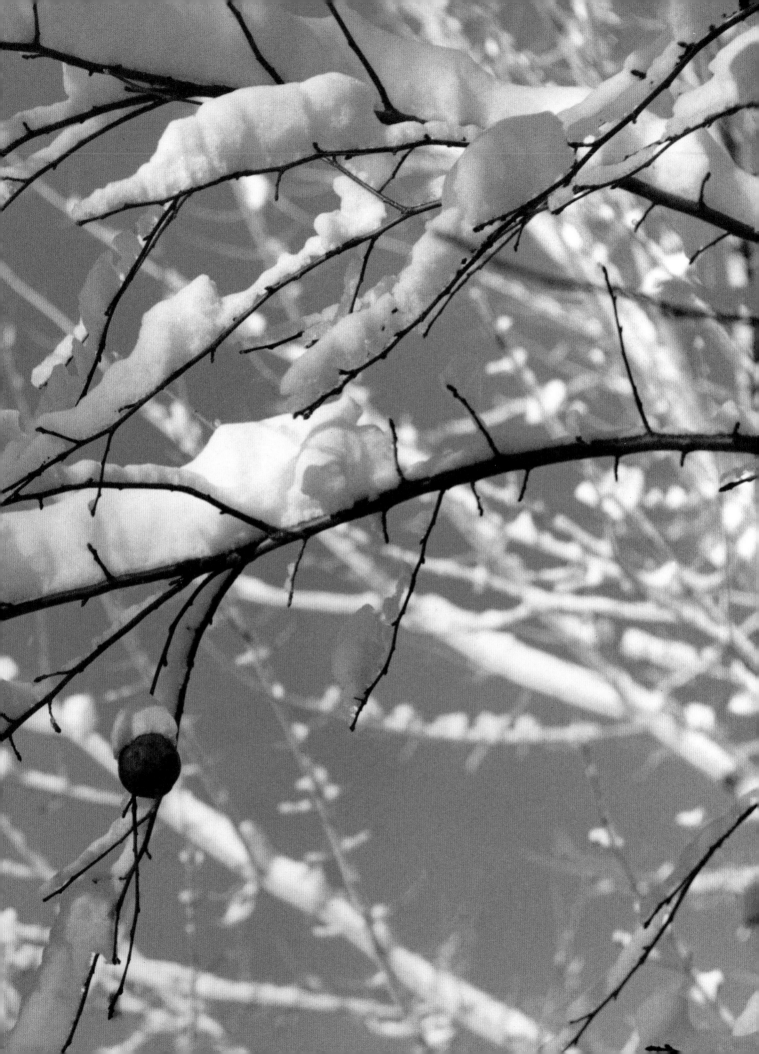

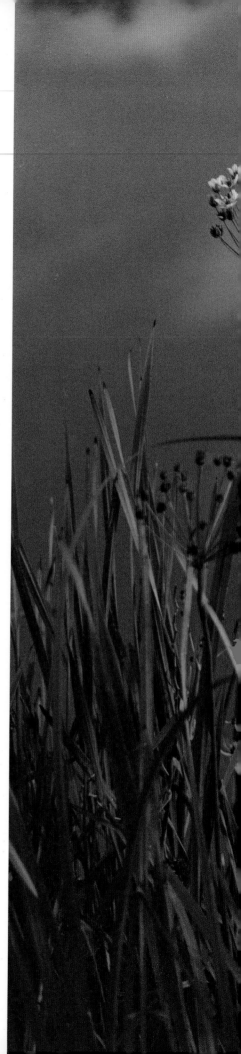

from The Tuft of Flowers

But he turned first, and led my eye to look
At a tall tuft of flowers beside a brook,

A leaping tongue of bloom the scythe had spared
Beside a reedy brook the scythe had bared.

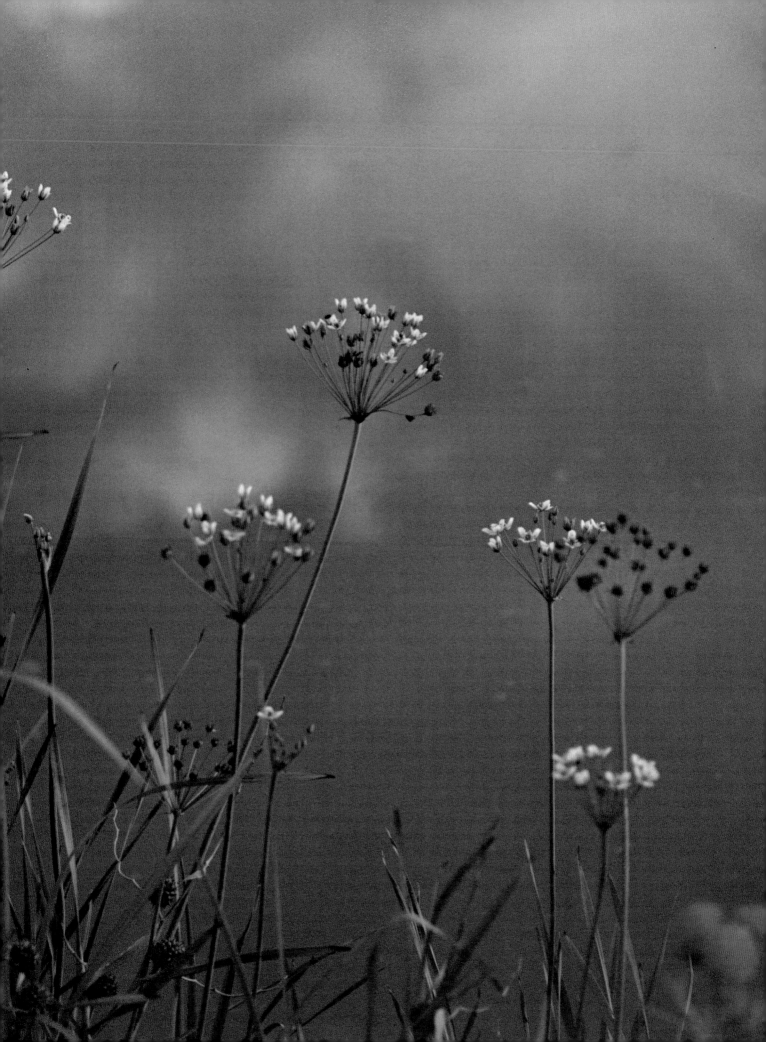

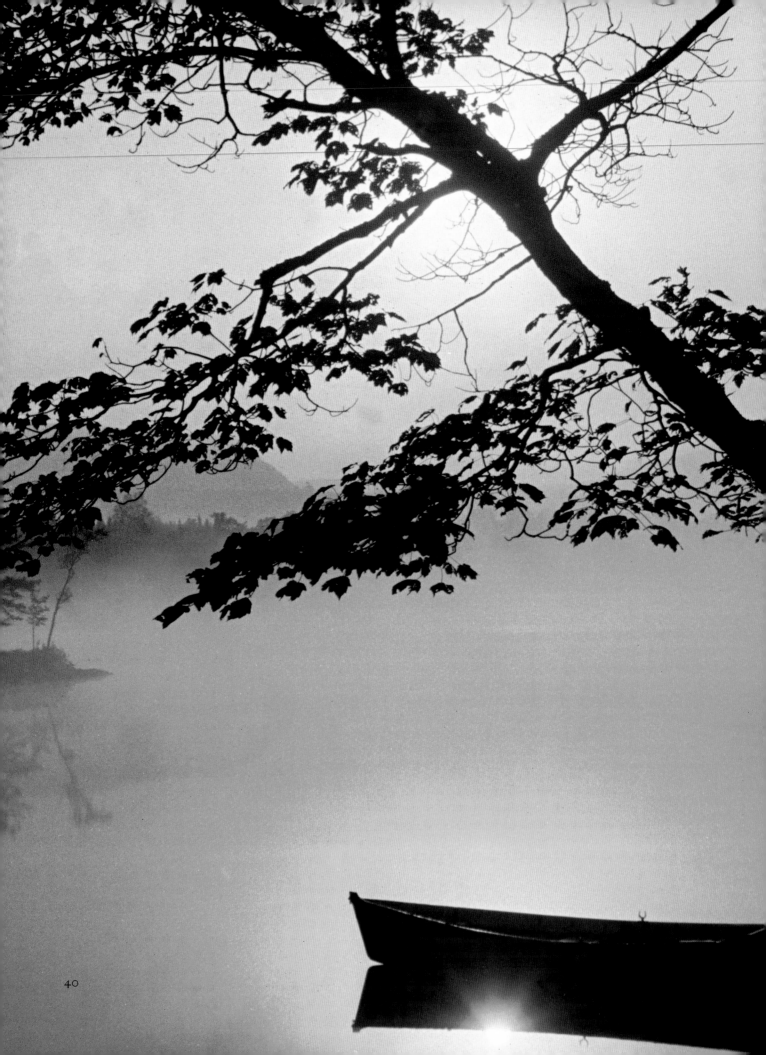

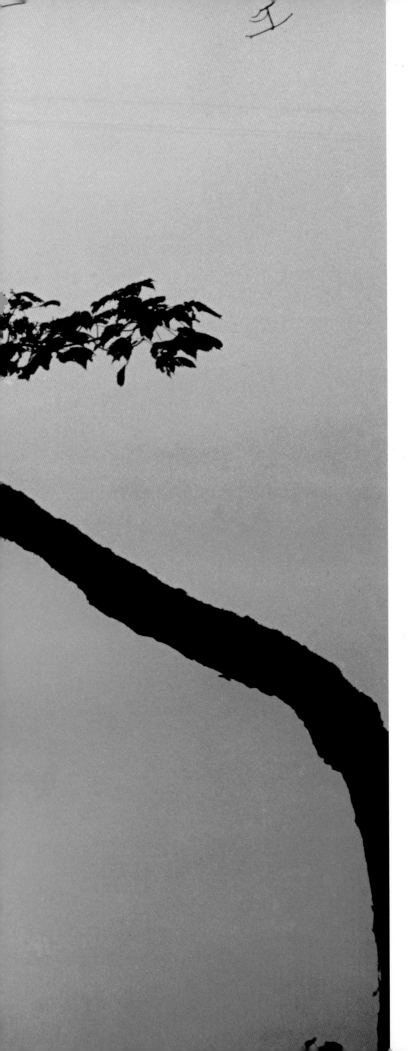

from The Trial by Existence

The light of heaven falls whole and white
 And is not shattered into dyes,
The light for ever is morning light;
 The hills are verdured pasture-wise . . .

from The Tuft of Flowers

And dreaming, as it were, held brotherly speech
With one whose thought I had not hoped to reach.

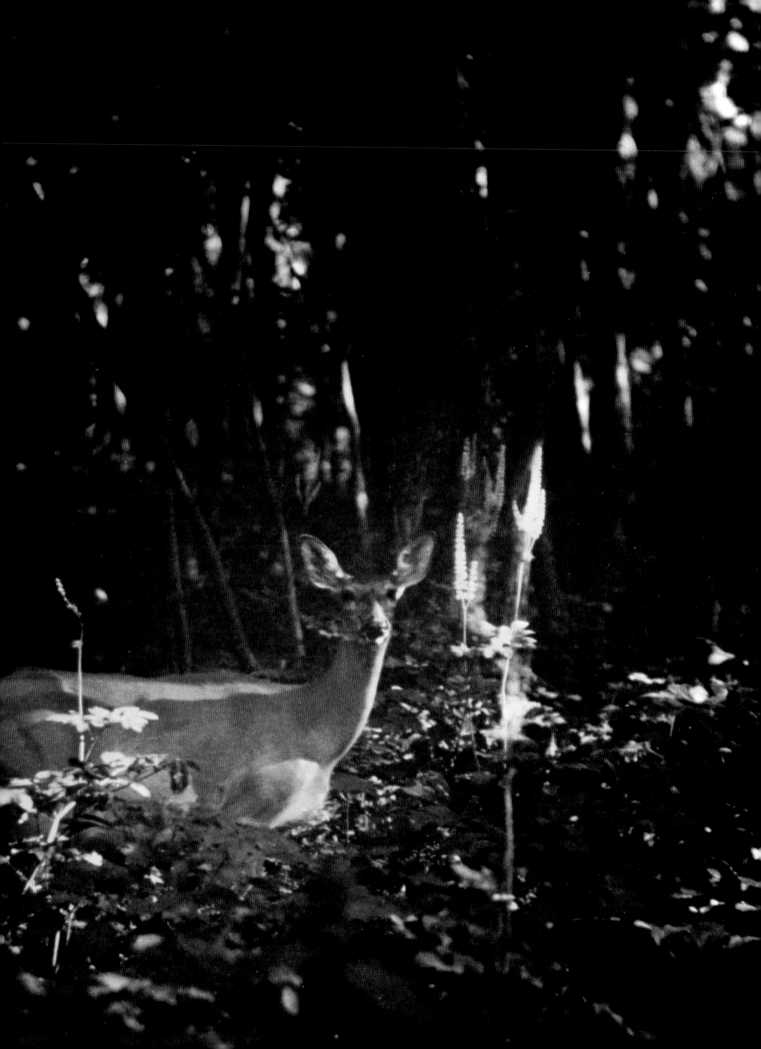

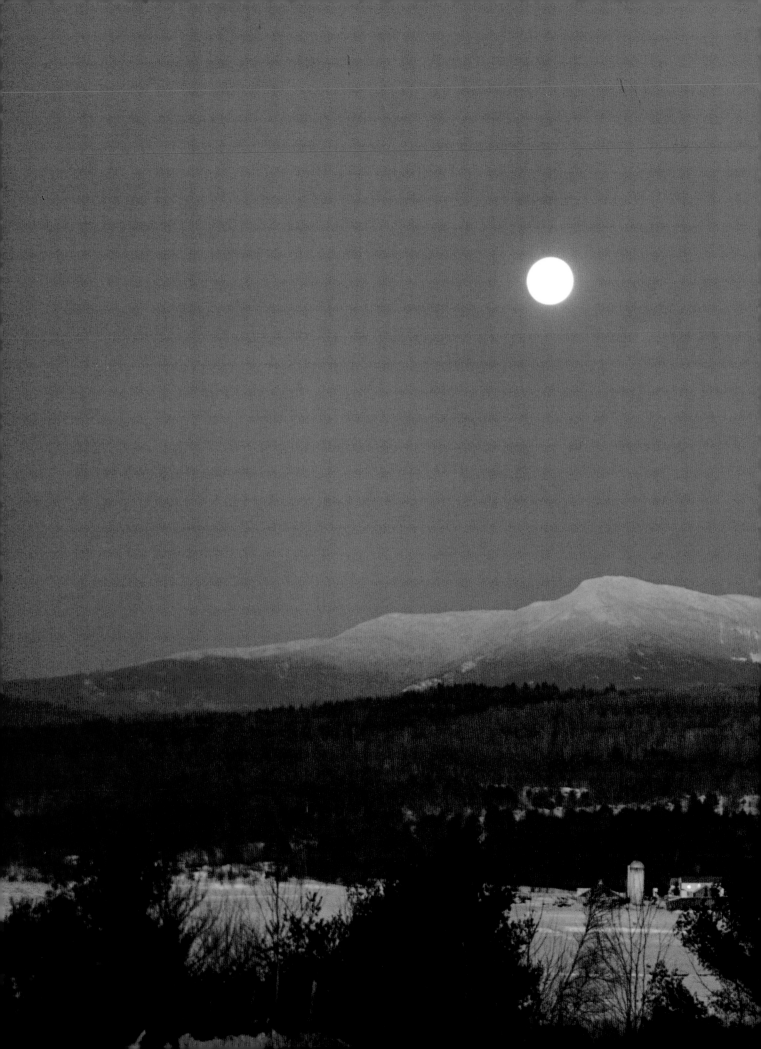

from The Mountain

 the town of my sojourn
Beyond the bridge, was not that of the mountain,
But only felt at night its shadowy presence.

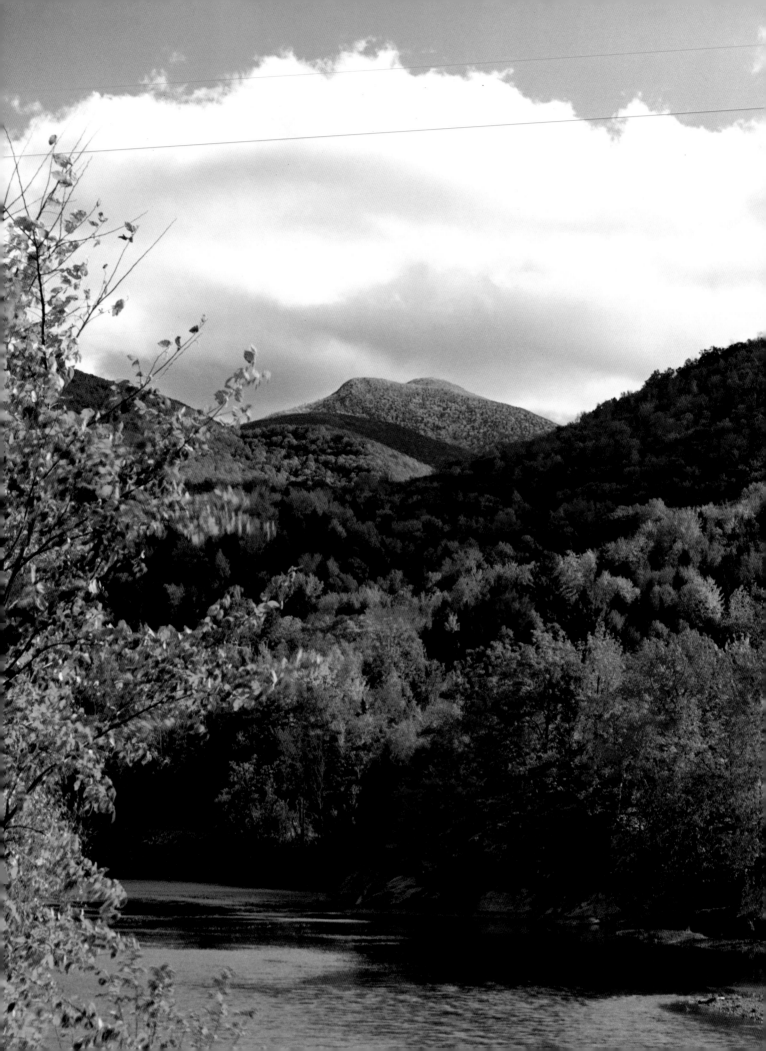

from October

O hushed October morning mild,
Thy leaves have ripened to the fall . . .

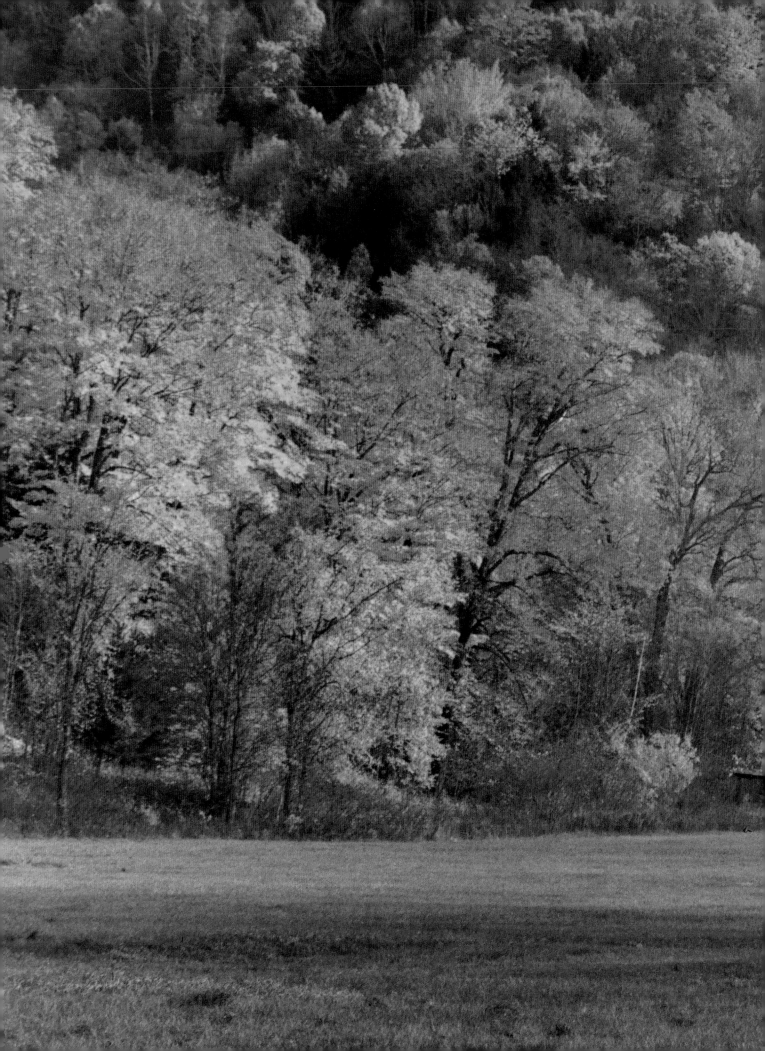

from October

To-morrow's wind, if it be wild,
Should waste them all.

from The Falls

'Tis a steep wood of rocks,
With the fern grown everywhere;
But with no birds—not a wing!
And the falls come down there.

Even an Indian trail
Would swerve to a haunt so fair!
One used to—there were the ferns
And the falls came down there.

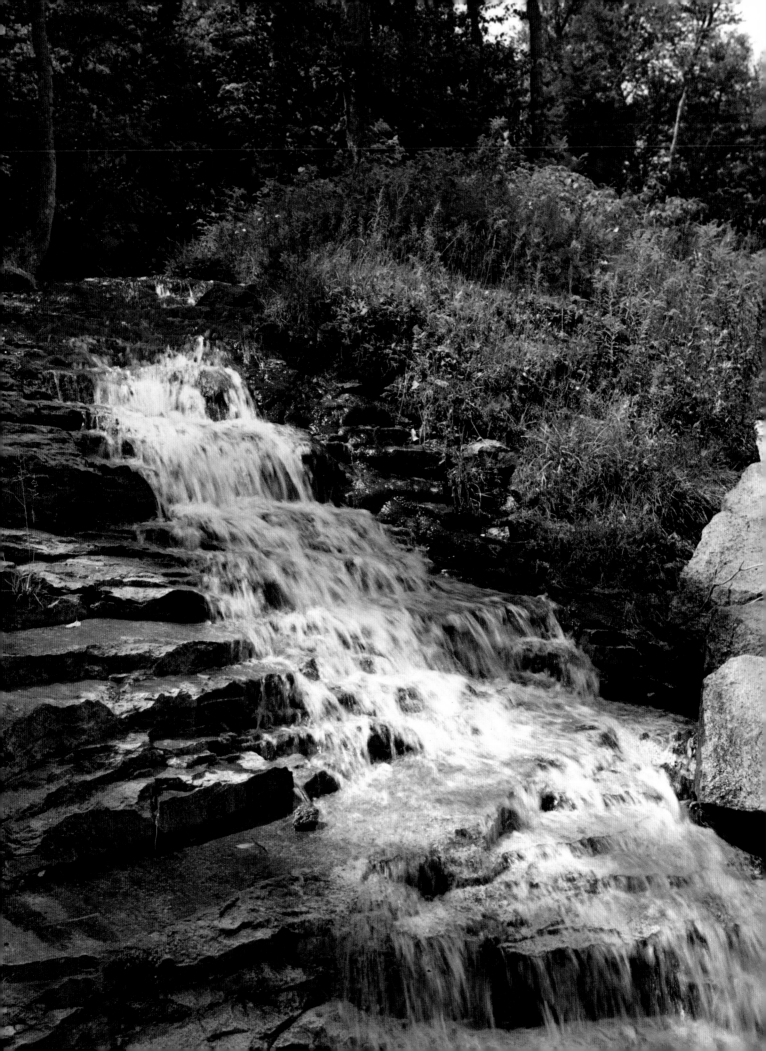

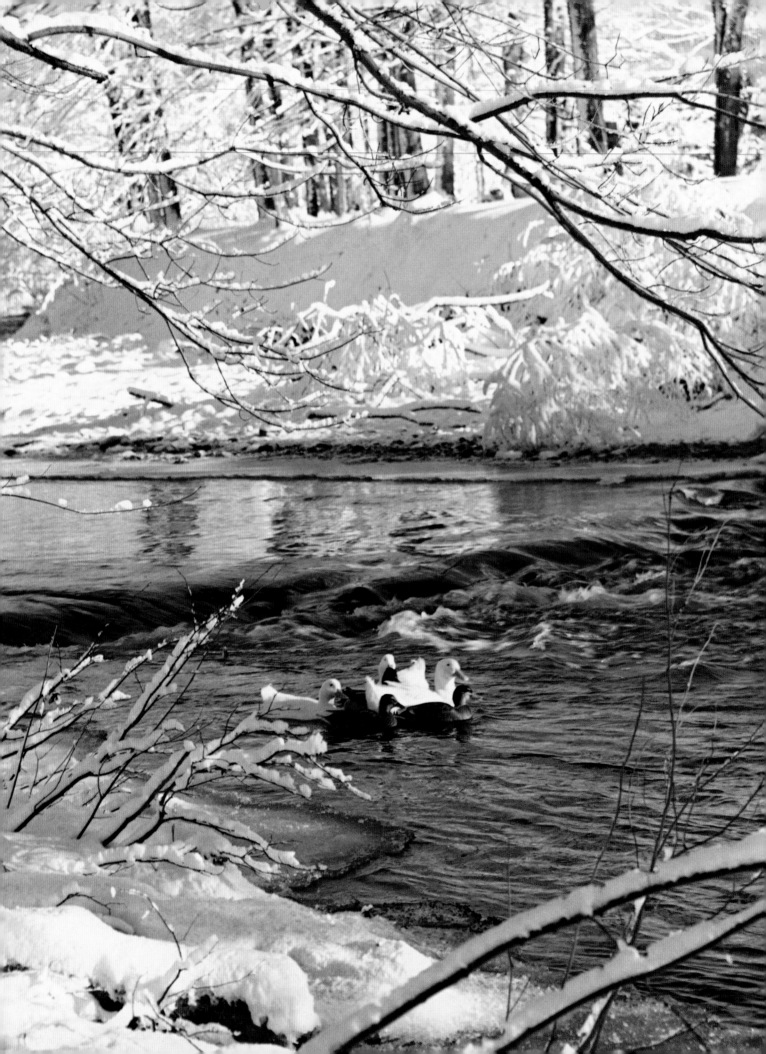

from The Onset

Yet all the precedent is on my side:
I know that winter death has never tried
The earth but it has failed: the snow may heap
In long storms an undrifted four feet deep
As measured against maple, birch, and oak,
It cannot check the peeper's silver croak;
And I shall see the snow all go down hill
In water of a slender April rill . . .

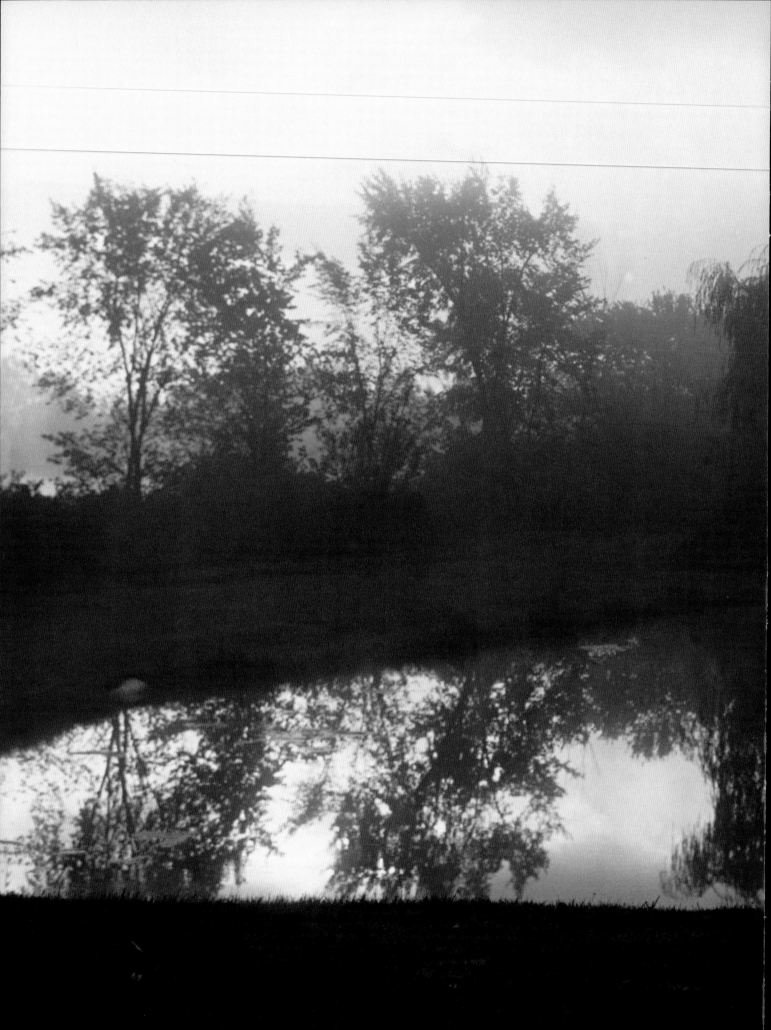

from Summering

I would arise and in a dream go on—
Not very far, not very far—and then
Lie down amid the sunny grass again,
And fall asleep till night-time or next dawn.

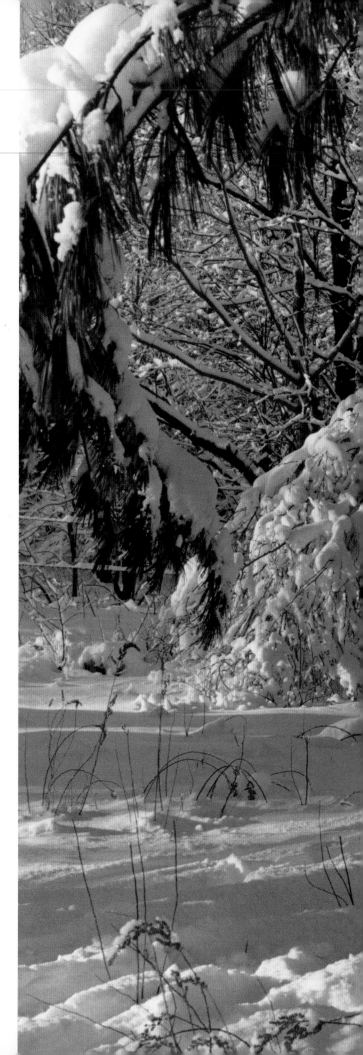

from Birches

When I see birches bend to left and right
Across the lines of straighter darker trees,
I like to think some boy's been swinging them.
But swinging doesn't bend them down to stay.
Ice-storms do that. Often you must have seen them
Loaded with ice a sunny winter morning . . .

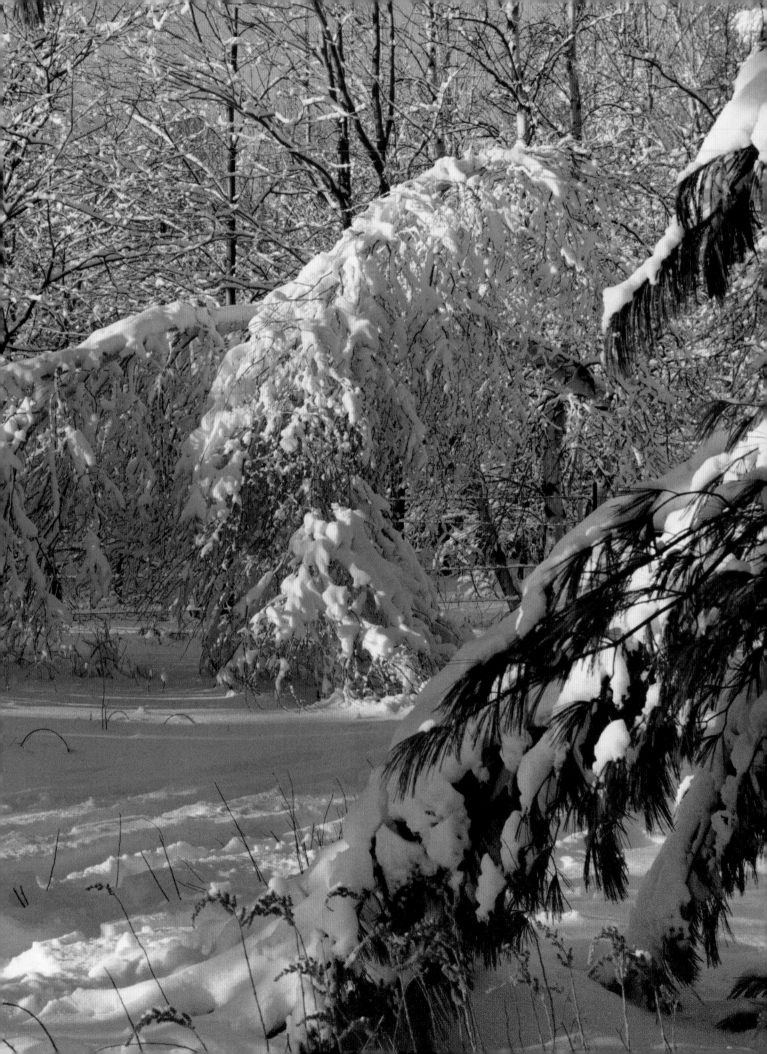

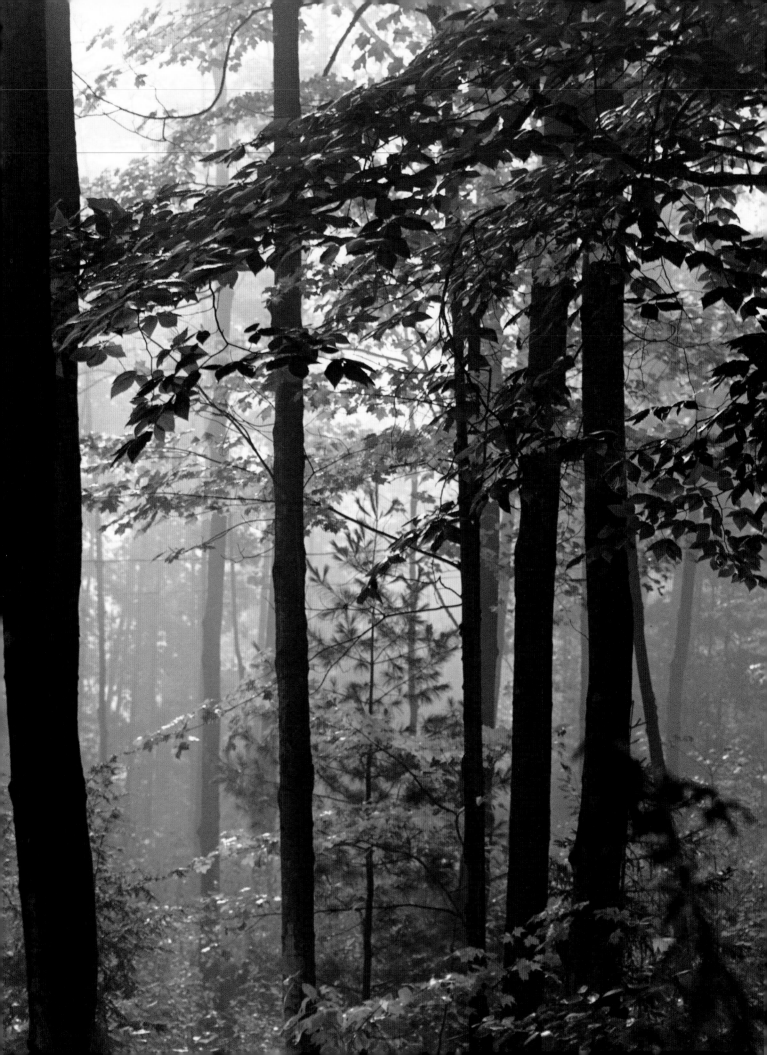

from The Wood-Pile

 The view was all in lines
Straight up and down of tall slim trees
Too much alike to mark or name a place by
So as to say for certain I was here
Or somewhere else: I was just far from home.

from Birches

I'd like to go by climbing a birch tree,
And climb black branches up a snow-white trunk
Toward heaven, till the tree could bear no more,
But dipped its top and set me down again.
That would be good both going and coming back.
One could do worse than be a swinger of birches.

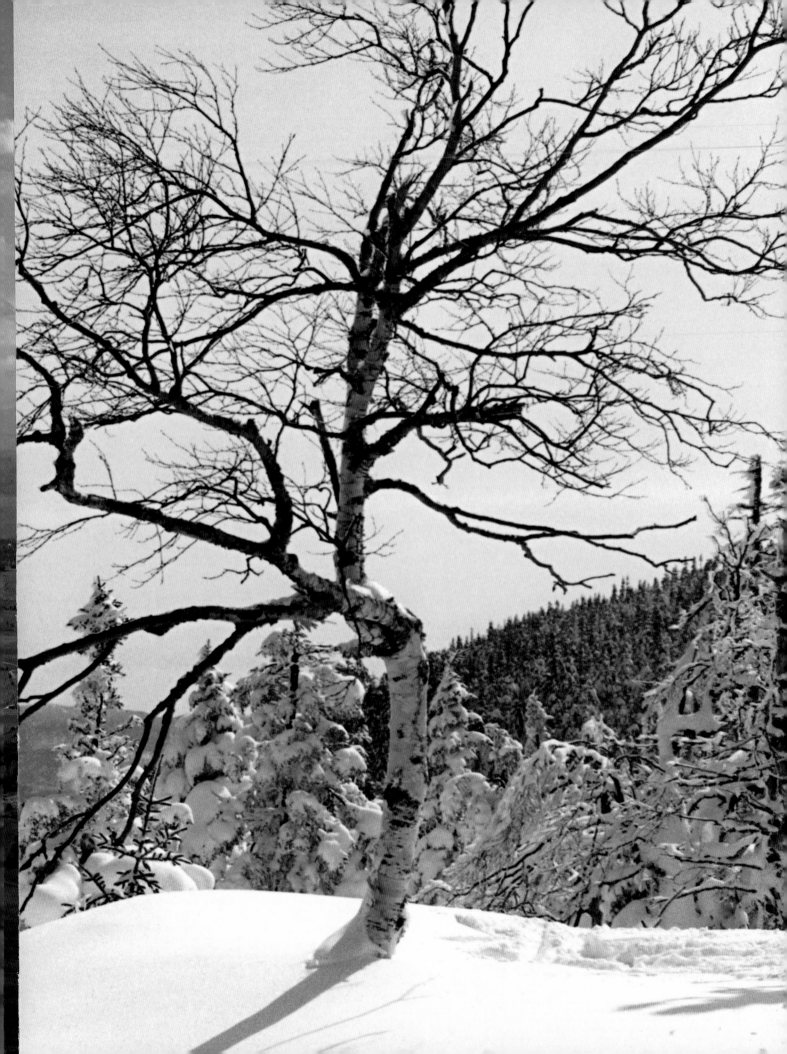

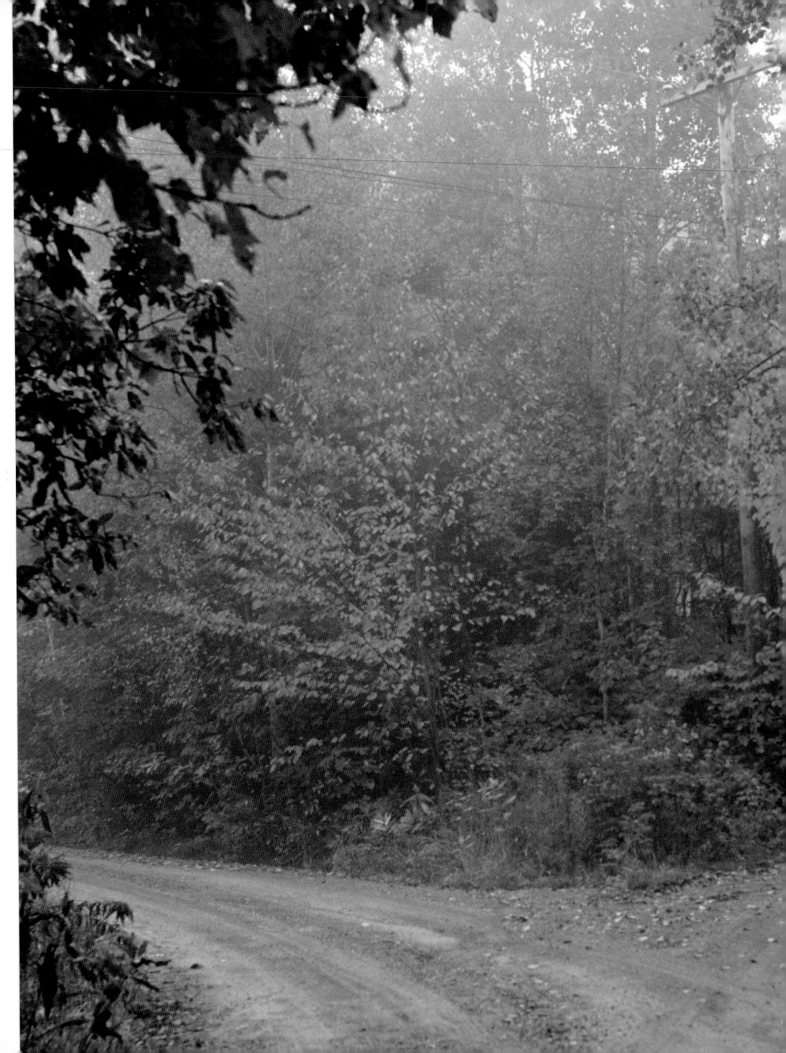

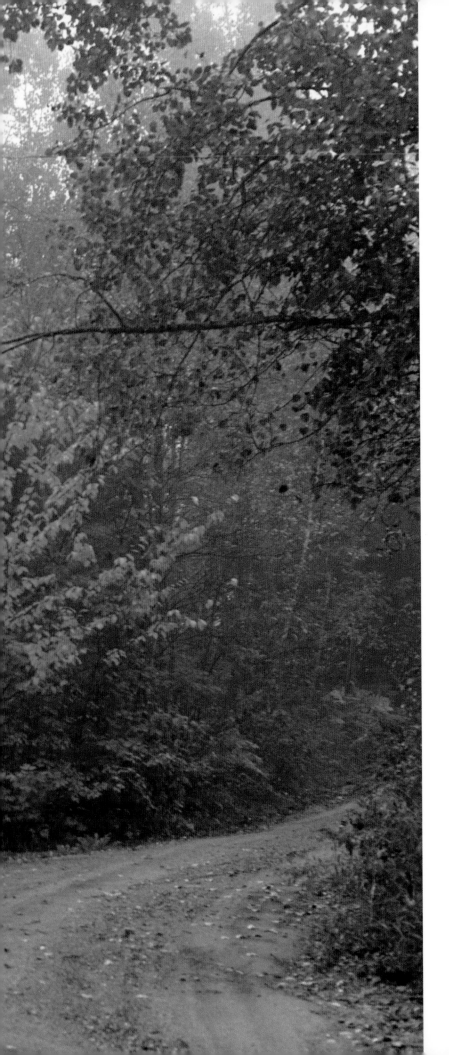

The Road Not Taken

Two roads diverged in a yellow wood,
And sorry I could not travel both
And be one traveler, long I stood
And looked down one as far as I could
To where it bent in the undergrowth;

Then took the other, as just as fair,
And having perhaps the better claim,
Because it was grassy and wanted wear;
Though as for that the passing there
Had worn them really about the same,

And both that morning equally lay
In leaves no step had trodden black.
Oh, I kept the first for another day!
Yet knowing how way leads on to way,
I doubted if I should ever come back.

I shall be telling this with a sigh
Somewhere ages and ages hence:
Two roads diverged in a wood, and I—
I took the one less traveled by,
And that has made all the difference.

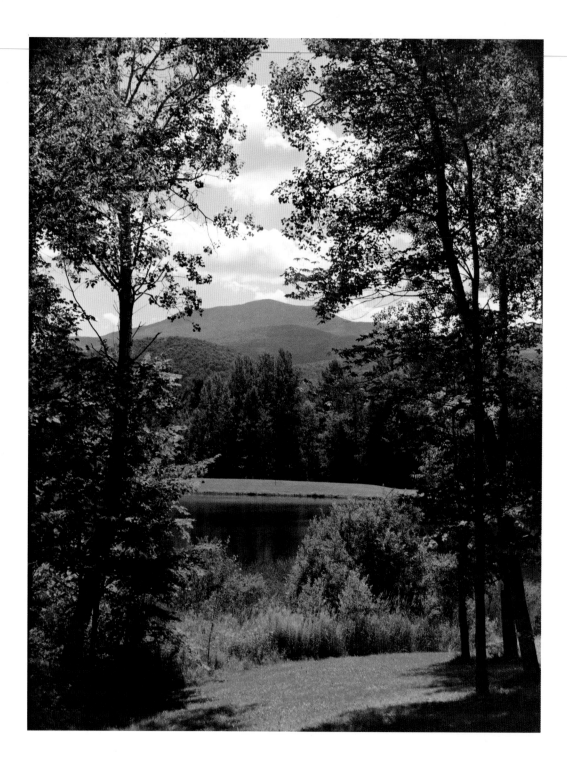

Notes on Photographs

JACKET FRONT: **Autumn Mirage** (Dixville Notch, New Hampshire). A slice of light momentarily accentuated this dramatic doubled image.

JACKET BACK: **Layers of Beauty** (South Pomfret, Vermont). At this point on the Appalachian Trail, the angle of light gently emphasized the tiered landscape. This area is part of the Appalachian Mountains, which spread from southern Quebec to northern Alabama.

i. **When the People Hibernate** (Waits River, Vermont). Although this is a much-photographed town, I like to think mine are just a bit different. I now have one good view each of three seasons and am looking for the fourth. Unfortunately, the weather here at home is not necessarily what I find when I arrive in Waits River.

ii–iii. **Where the People Live** (Waits River, Vermont). After I had made this photograph, I met a dear lady who belonged to the church in the picture. She remarked, "If our church only had *one dollar* for every photograph that was taken of our building, we'd have *lots* more money!" This reminded me of the farmer who has a locked box at the top of his hill, a spot where hundreds of photographers go each season, so that those who make money from his farm can contribute to its upkeep. In his case, as with the Waits River view, the resulting photographs have been used for calendars, note paper, cards, ads, and even the enormous blown-up versions Kodak features in Grand Central Station. We photographers too often forget to say "thank you."

vi. **The Span of Seasons** (Jericho, Vermont). Those of us who love New England especially enjoy the changing seasons. At this particular moment—with the greens, fall foliage, and early snow—I felt I was seeing three seasons.

x. **Frost's Cabin** (Ripton, Vermont). During the years Frost spent here, he helped found the Bread Loaf Writers' Conference, which is associated with Middlebury College.

I. **Peace in the Country** (Jericho, Vermont). Another "road less traveled." I made the photograph with my then-new 35 mm Olympus Stylus with 35-70 mm zoom lens. Normally I use my "antique" twin lens reflex, a Mamiya C330 Professional, which I like; but now I am finding the convenience of 35 mm lots of fun.

3. **Quiet Habitat** (Springfield, Massachusetts). This was the first of several photographs of fading autumn foliage that I made early one morning en route from Massachusetts to our home in Vermont. ("Forest Murmurs" was the last in the series.)

4–5. **Winter Sculpture** (Madonna Mountain, Jeffersonville, Vermont). I was fascinated by this snow formation at the top of a ski trail. It was hard to believe that back in the city Vermont's March "Mud Season" had begun.

6–7. **Midnight Reverie** (Lake Dunmore, Vermont). Tom often has said, "The only way to photograph me is from behind at midnight." I didn't think about his words when I enlisted his help in photographing this spot where we could see house lights as well as moonlight reflected on the water. (I had learned that if you want people to believe it is *moon*light and not a darkroom trick with a sun in the photograph, house lights are necessary.) The moving clouds during the three-minute time exposure created the effect of an aurora borealis. When you "push" the film, the colors change in the finished work. I did not use a filter.

8–9. **Bounteous Nature** (West Corinth, Vermont). Most of my photographs are taken "between here and there," unscheduled and unplanned. On this day I was out looking for new areas. How could I leave my camera in the car?

10–11. **Twinkling Forest** (Ripton, Vermont). Frost must have loved this scene along the Middlebury River, not far from his summer cabin.

12–13. **Sugar House** (Reading, Vermont). In photography school ('65), while the other students were busy photographing the famous Jenne farm, I was across the street taking this photograph, which has remained a favorite.

14–15. **Walling In or Walling Out?** (South Pomfret, Vermont). After I had created the prototype for this book, I wanted one more photograph of a stone wall—and I knew exactly where to go. I arrived just before the sun disappeared.

16–17. **In Nature's Realm** (South Pomfret, Vermont). Did the original owner decide not to build a wall that completely separated him from his neighbor? This photograph was taken on the same property as "Walling In or Walling Out?" The play of light intrigued us. This is the newest (and only the third) photograph in our line taken with my Olympus.

18–19. **Madonna Meringue** (Madonna Mountain, Jeffersonville, Vermont). I made this photograph at the top of a ski slope on a March day in the '60s. It ran on the front page of our local newspaper, whose editor gave it this title.

20–21. **Pending Storm** (Madonna Mountain, Jeffersonville, Vermont). Taken on the same day as "Madonna Meringue," this picture proves how much hovering clouds can change the feeling of a scene.

22–23. **When Time Stands Still** (Jericho, Vermont). Less traveled roads are always intriguing. An earlier photograph of a snowy road had been favored for years, but I was overjoyed to capture this brighter, whiter aura.

24. **Elders' Council** (Madonna Mountain, Jeffersonville, Vermont). At ski areas I have had to decide whether to carry my Rollei or to ski. The answer this day was to do one run with my camera.

About the Authors

Betsy Blake Melvin, born in Springfield, Massachusetts, started taking photographs on her eleventh birthday. At sixteen, her picture of a camp bugler appeared in the *Christian Science Monitor*. Photography remained a hobby and a sideline throughout her years in Vermont Junior College and Principia College in Illinois. She graduated from Principia in 1944. Twenty years later, she went into photography as a profession, exhibiting and selling her "Poetic Pictorial Photographs" of New England scenes. Betsy has won many regional and national awards, as well as an honorary master of fine arts degree from Norwich University. In 1979, Eastman Kodak's trade journal, *Studio Light,* featured Betsy as one of eight women in the United States whose creative concepts and marketing skills contributed significantly to professional photography.

Tom Melvin, born in Vienna, also began taking pictures at age eleven. He first exhibited a photograph, in the window of a camera shop, at age thirteen. He later studied photography in Vienna, Lisbon, New York, and Philadelphia. After serving with the U.S. Signal Corps in the China–Burma–India theater during World War II, Tom settled in Philadelphia, where he established a photography studio and raised his family. After twenty-six years there he met Betsy at a photographers' convention in 1971. Five days later they decided to make their life together and establish The Artistic Alliance. Their earlier book, *Robert Frost Country* (Doubleday, 1977), contained the first photographs the Frost Estate authorized for use with Frost's poetry. Today the Melvins live in Essex Center, Vermont, where they maintain their portrait studio and gallery.